173910

Segers, Hercules

Hercules Segers

DATE DUE

Hercules Segers

HERCULES SEGERS

by John Rowlands

George Braziller
New York

To my Friends

Published in the United States in 1979 by George Braziller, Inc.
Copyright © 1979 by John Rowlands

All rights reserved.
For information address the publisher:
George Braziller, Inc.
One Park Ave.
New York, New York 10016

Library of Congress Cataloging in Publication Data
Segers, Hercules, 17th cent.
 Hercules Segers.
 Bibliography: p.
 1. Segers, Hercules, 17th cent. I. Rowlands,
John, 1931–
NE2054.5.S43A4 1979 760'.092'4 78–26815
ISBN 0–8076–0909–9

Printed in West Germany
First edition

Designed by Lorraine Wild

Contents

Acknowledgments

In writing this book, I have received generous help from many quarters and in the assembly of reproductions, willing assistance has come from institutions, colleagues, and friends. In particular, I would like to express my gratitude to Mrs. Rosi Schilling for her enthusiastic help and kindness during the preparation of successive versions of the text. Señor Fernando Zobel de Ayala, at a critical juncture, gave me a haven of calm, enabling me to complete the manuscript. From the first, he has been a keen supporter of the project, and I have profited greatly from discussions with him on Segers's printmaking. Both of us were saddened to discover that the extraordinarily desolate landscape of Lanzarote, one of the Canary Islands, could not possibly have inspired the artist, since it was the result of a volcanic explosion many years after his death. A conjecture that Segers journeyed to these islands was therefore reluctantly abandoned. Professor Seymour Slive was good enough to cede the privilege of publishing the remarkable painting, the *Skull*, whose owner has given the author his unstinting cooperation. Mr. and Mrs. Stuart Cary Welch and Miss Eleanor Sayre treated me most kindly when I visited the United States. Captain Edward Speelman has also been very helpful. Finally, I owe a great deal to the work of Egbert Haverkamp Begemann, whose significance for all future writers on Segers will inevitably be considerable.

The publisher and author wish to express their grateful thanks to all the public institutions and private collectors who have given their support by granting permission for the reproduction of works in their possession: the Rijksmuseum, Amsterdam; the Trustees of the British Museum; the Staatliche Museen, Berlin-Dahlem; the Museum of Fine Art, Budapest; the Wallraf-Richartz Museum, Cologne; the Kupferstich-Kabinett, Dresden; the Uffizi, Florence; the Mauritshuis, The Hague; the Hermitage Museum, Leningrad; Edward Speelman, Ltd., London; the Bibliothèque Nationale, Paris; the Musée du Louvre, Paris (Cabinet d'Estampes, Edmond de Rothschild). To those collectors who have preferred to remain anonymous, we proffer thanks for their kind cooperation.

Preface

There is no Introduction available to the work of Hercules Segers which is addressed to the general reader. I have been long aware of this gap in the literature, and it was a pleasant surprise to be invited to write just such an introductory book on him. My purpose is to make a generous selection of his paintings and prints accessible in reproduction for the first time to a wider audience. An important consideration in writing about Segers has been to endeavor to explain the true nature of his originality. As it has turned out, my anticipation of this task was more daunting than the reality. Many aspects of his printmaking can, in fact, be described in a straightforward way, for most of the means that Segers employed are not complicated. It is the manner in which Segers has combined in his prints the use of etching and drypoint in various colored inks with watercolor, oil and bodycolor on a variety of different surfaces which constitutes a decisive and revolutionary step. But the magical results that he has obtained from this amalgam can hardly be captured by a writer, unless he were perhaps blessed with the imaginative power of a John Milton. Difficult points of details surround certain prints with an aura of technical mystery, which by their very nature are likely to be a matter for debate among specialists. Such questions are not for the general reader. As they could undoubtedly lead to confusion, their discussion has been avoided as much as possible; otherwise I believe one might well be putting up unnecessary barriers to a ready appreciation of the essential quality and beauty of Segers's art.

Introduction

The work of Hercules Segers is of such extraordinary and haunting beauty that it deserves to be much more widely known and appreciated than it is at present. Indeed, there are few artists who are so highly regarded by a small coterie of informed specialists, but who remain, at the same time, virtually unknown to the general public. The purpose of this book is to introduce the reader to the paintings and etchings of Segers. As with all great art, the trouble taken to understand its character will be richly rewarded, for one can return to it again and again for spiritual refreshment.

 The art of Segers is introspective, possibly even melancholic, in mood. The atmosphere in his paintings and etchings contrasts sharply with that in the art produced by his contemporaries in Holland. Segers was born and grew up at a time when the newly free Northern Netherlands, what we now call Holland, was experiencing a veritable explosion of artistic expression. In these first decades of the seventeenth century, a time of self-confidence and increasing economic well-being, a vast array of paintings was produced to satisfy an insatiable popular demand. Apart from portraiture, the chief fields in which Dutch artists excelled were landscape painting and engraving. Although Segers was a part of this great flowering, his paintings, and more especially his prints, are at variance with the landscapes of his fellow artists, who laid more stress than he did on the accurate recording of nature. While the greatest of the younger generation, such as

Jacob van Ruisdael, often captured the varying moods of nature, Segers's landscapes appear instead to reflect the changing moods of the artist. The purpose of this introduction is to make the substance of Segers's originality more widely felt, and his distinctive technical innovations better understood. But, before doing so, it would be as well to survey the all too scanty details which are known about the artist's life.

 Because of the lack of solid data about Segers, legend and fanciful interpretations were invented at quite an early date to embellish the bare facts. Although the spelling of the name as "Seghers" is occasionally found in seventeenth-century documents and has been used by most modern writers, the artist signed himself "Segers" and sometimes spelt his Christian name "Herkeles." In the earliest documents he is referred to and signs himself "Hercules Pietersz" without the surname. From later documents we can deduce that he was born in Haarlem, either in 1589 or 1590, the son of Cathalina Hercules and Pieter Seghers, a Mennonite from Flanders who probably fled to Holland to escape religious persecution. A document dated January 1607 records a Pieter Segers who was in debt for his son's apprenticeship to the estate of Gillis van Coninxloo, the landscape painter. This debt and the fact that in March of that same year a "Hercules Pietersz" bought drawings, prints, and *een geberchte* (a painting of a rocky landscape) at the sale of

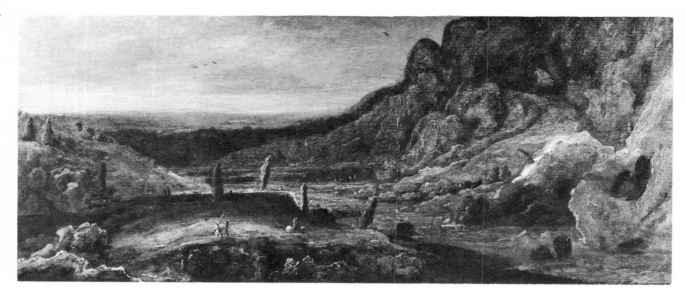

I

Hercules Segers (Before 1620)
Mountain Valley, Trautscholdt 11
Oil on panel 22.5 x 53 cm.
The Mauritshuis, The Hague

Coninxloo's estate supports the idea that Segers was trained by him.

In 1612, "Hercules Pietersz" entered the painters' guild in Haarlem. By December 1614, he was living in Amsterdam and was engaged to Anneken van der Brugghen from Antwerp, whom he married the following month. Sometime earlier, he had agreed to assume responsibility for the care of his illegitimate daughter, born to Marritge Reyers. In 1619, Segers bought a rather expensive house on the Lindengracht in Amsterdam. As he appears to have been in debt before his marriage, it is quite possible that his wife was well-to-do and paid for the property. In one of his etchings (Plate 36) he has recorded the view from a window of his new home, and there is a partial repetition of this view in his painting, *River Valley with Houses* (Plate 2).

He is first referred to as "Hercules Segers" in 1621. Evidently he remained in Amsterdam until 1631, when, because of serious financial difficulties, he was forced to sell his house at a considerable loss. After this, he is recorded picture-dealing in Utrecht. The last direct reference to Segers of 1633, cites him living at The Hague. Although a 1638 document identifies a Cornelia de Witte who was living at The Hague as the widow of Hercules Pietersz, the reference is inconclusive, since her late husband's profession is not mentioned and since Segers's only marriage on record was to Anneken van der Brugghen.

Additional information about Segers's life can also be gleaned from contemporary references to his paintings. Evidently they were appreciated by fellow artists, for in 1627 two of Segers's paintings were mentioned in the estate of the Amsterdam painter, Louys Rocourt, while another, entitled *The Waterfall*, belonged to Herman Saftleven the Elder who died in the same year. A Segers painting was in a collection offered to the King of Denmark in about 1621, and in 1632 the House of Orange acquired two of his landscapes. Although the facts seem to suggest that Segers enjoyed a certain reputation as a painter during his lifetime, they do not necessarily imply that he enjoyed financial security. Indeed, few Dutch artists of his day could live solely on their income from painting.

After his death, Segers's paintings were soon very much in demand, and the prices they fetched rose considerably. By 1640 the Amsterdam dealer Johannes de Renialme is said to have had no less than twenty-one paintings by Segers and twelve "rolled-pieces," variously interpreted as either unmounted canvases, or as etchings. Records show that Rembrandt owned eight paintings by Segers in 1656, one of which was almost certainly the large *Mountain Landscape* (Plate 3), acquired in the nineteenth century by the Uffizi, and then attributed to Rembrandt. In 1680, the estate of the artist Jan van de Capelle contained five paintings by Segers, including *Brussels Seen from the Northeast* (Plate 42).

Unfortunately, we have no clues about Segers's reputation as an etcher during his lifetime, and it seems very probable that those of his prints which have survived were originally gathered in a few large, privately owned and therefore inaccessible groups. This inaccessibility partly explains their minimal influence on later artists. It is very doubtful that more than a handful of people saw Segers's prints while he was alive, or even in the period following his death. The most crucial point is, however, that Segers appears to have kept the secrets of his etching experiments to himself. There is no evidence from his immediate followers that Segers passed on the technical innovations which derived from his experiments. Even the work of Ruischer, who appears to have been the only artist who may have been Segers's pupil, gives no hint of this. With this link missing, Segers's example was not followed, and his discoveries had to be made afresh in the eighteenth century by a few artists.

One group of Segers's prints, it seems, was in the possession of Jacob Houbraken (1698 – 1780) and, it has been plausibly suggested may have previously belonged to Samuel van Hoogstraeten (1627 – 1678) who was a pupil of Rembrandt after 1640. Unlike other seventeenth-century writers on art, van Hoogstraeten devotes considerable attention to Segers's prints in his *Inleyding tot de Hooge Schoole der Schilderkonst* ("Introduction to the High School of Painting") of 1678. He had first-hand knowledge of Segers's prints, and elaborated the biography somewhat to satisfy his readers along traditional lines.

Van Hoogstraeten's account of Segers's life is included in a chapter entitled "How the artist should behave in the face of adverse fortune." According to van Hoogstraeten, Segers fought an unequal struggle against bad luck. Van Hoogstraeten lamented that there was no market for Segers's prints and that the world failed to recognize an artistic imagination "pregnant of whole provinces." To his wife's despair, the artist was forced to use the household stock of linen for his paintings and prints. Despite everything he did, such as selling fragments of his copper plates, Segers was dogged by misfortune. Eventually he took to drink for consolation, so the story goes, and one evening coming home in a drunken stupor, fell down the stairs to his death. The biographer thus gives to Segers the standard attributes of the luckless genius, "born under Saturn" and subject to bouts of despair. The neglect of his prints and their use as wastepaper was a fate typical of such an unsuccessful artist. Van Hoogstraeten may have exaggerated for the sake of tidiness, giving Segers a sorry, but predictable, end. Knowing that Segers's work fetched higher prices after his death, the author's account was certainly colored by hindsight. On the other hand, van Hoogstraeten failed to mention Segers's success as a painter, about which we know from other sources. This omission

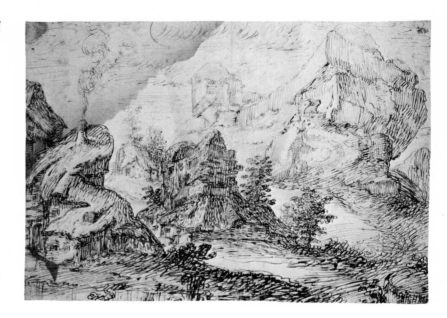

Hendrik Goltzius (1558–1617).
Fantastic Landscape.
Pen and brown ink. 27.8 x 39 cm.
British Museum, London.

suggests that the author deduced the course of Segers's career solely from his knowledge of the prints. Here, van Hoogstraeten accurately reported that Segers sometimes "printed" paintings on linen, that he pulled only a few impressions from each plate, and that he often cut up his copper plates.

The number of paintings attributed to Segers and universally recognized as his is small. Scholars have tended to become more and more restrictive in their opinions of what is acceptable as Segers's work, and this is almost as true of the etchings as of the paintings. Although this undoubtedly affords us a much clearer view of Segers's *oeuvre,* many questions still surround his activity. For instance, it is not certain whether he worked simultaneously as an etcher and as a painter. His apprenticeship to Gillis van Coninxloo, a landscape painter, suggests that Segers began his career as a painter; however, Segers's entry into the Guild of Haarlem in 1612, alongside Willem Buytewech and Esaias van de Velde, both of whom were active as landscape etchers, makes it not only possible, but also likely, that Segers would have been excited by their example. Furthermore, there was the influence of Haarlem's presiding genius, Hendrik Goltzius, whose chiaroscuro woodcuts could, in some respects, be regarded as the forerunners of Segers's colored etchings of mountain landscapes. Even though the dates of the etchings are not known, it is not impossible that Segers began to produce prints in Haarlem.

At first sight, the *View from a Window of Segers's House* (Plate 36), already mentioned, would seem to give us a clue to the dating of his work. Because the *Noordenkerk* seen through the window was more or less complete in 1623, it seems plausible to assume that the etching dates from the artist's Amsterdam stay from 1621 to 1631. But as Segers also produced a painting of the same subject, listed at the beginning of the eighteenth century in the collection of Allaert van Everdingen, the print could have been executed after this missing painting at any later date.

A dozen or so paintings, four of which are signed, have survived. All of them are landscapes, except for a recently discovered painting, the *Skull* (Plate 1). In 1663, a painting of a skull was left to the Amsterdam Surgeon's Guild by Jan Zeen. The administrators of the guild sold it, attributed to Rembrandt, at auction in September 1853, and it disappeared from view after the collection of H. J. Boers of Utrecht was sold in March 1873. The appearance now of such a painting is therefore a matter of some moment. It was acquired by its present owner from the Victor D. Spark Gallery, New York and before that had been in a collection in New Haven, Connecticut. The extant painting of a skull is attributable to Segers on stylistic grounds, but its dimensions (28 x 25.4 cm.) are different from those of the skull painting belonging to the Amsterdam Surgeons' Guild. The size of that painting (67 x 86

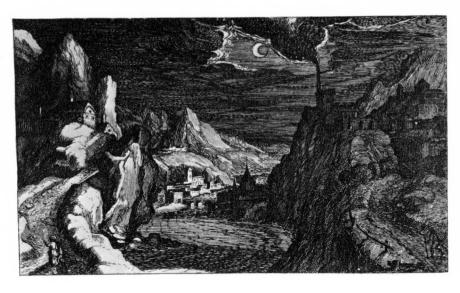

Simon Frisius (c. 1580–1624),
probably after Paul Bril (1554–1626).
A Moonlit Landscape.
Etching 9.7 x 15.8 cm.
British Museum, London

cm.), listed in the 1853 sale catalogue, suggests that the guild required a larger than lifesize representation of a skull for classroom teaching. Probably Segers executed more than one painting of a skull, and the painting listed in the Amsterdam Surgeons' Guild's 1853 catalog is not the same as the painting now in New England. What is important, however, is that the New England painting fully reflects Segers's very individual use of the brush and is undoubtedly attributable to him.

It is not inconceivable that Segers's etching of a skull, which survives in a single impression (Plate 74B), represents the same skull. Although an unusual subject for a print, the skull was frequently portrayed in allegorical still-lifes on the themes of Vanity and Mortality. Here, however, the skull is ostensibly represented as an anatomical object. Segers, according to an early account, is said to have executed his painting after a skull of someone "from a very distant country" that had been sent to the French king. Interest in recording both specimens and the results of scientific experiments was not new in Holland. Before the end of the sixteenth century, for example, Jacob de Gheyn the Younger (1565–1629) made drawings, both inside and outside the laboratory, of human and animal corpses. Segers has represented the skull as if he were exploring the terrain of a strange country. He succeeded in imparting to this object the same air of mystery he gave to his fantastic landscapes, in delineating both the caves and cre-

vices of its barren rock-like surface. Apart from the technical mastery and extraordinary sense of color evident in this painting, which allies it closely to the landscapes, especially *River Valley with Houses* (Plate 2), its unique blend of analytical inquiry mingled with an exciting sense of adventure assures us that this skull is a hitherto unknown work by Segers.

A *Virgin and Child* that has not yet come to light is the other recorded painting by Segers that is not a landscape. Religious themes do not appear to have been of any particular interest to Segers. Indeed, in the case of one religious print, *Lamentation over the Dead Christ* (Plates 4 and 49) after a woodcut by Baldung (Figure V), Segers's fascination with Baldung's strange feeling for space, which was somewhat akin to his own, evidently prompted the copy, rather than an interest in the religious theme itself.

Segers's landscapes range from imaginary views of deserted mountain valleys, surrounded by fantastic rock formations, to matter-of-fact records of Dutch villages, seen from a distance across the fields. Between these two extremes are views of ruined abbeys and castles, interpreted fancifully by Segers's experimental printing techniques, and fantastic mountain landscapes with incongruous groups of naturalistically rendered houses, frequently lifted from his other works. There has been much speculation as to

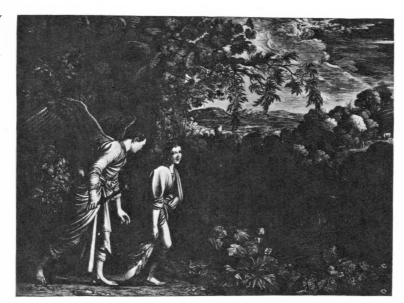

IV

Hendrik Goudt (d. after 1626).
Tobias and the Angel.
Engraving. 26 x 27 cm.
British Museum, London.

whether Segers's imaginary landscapes were inspired by a particular location. Various regions and even specific places have been proposed, but none can be proved. Many of the etchings portray barren, inhospitable landscapes. High, bare mountains surround valleys which are sometimes dotted with small houses that emphasize the towering heights above. The human element is either absent or is there just to give a sense of scale. The introduction of extraneous features, such as Dutch towns or windmills, makes it clear that Segers had no intention of representing the Alps or any other specific mountain region. The only case, in fact, of his recording a location outside Holland in a painting is found in his view of *Brussels seen from the Northeast* (Plate 42).

It would be more productive to consider the artistic sources of his fantastic landscapes. With Esaias van de Velde, whom Segers knew in Haarlem, he was heir to a tradition of landscape painting going back to Pieter Bruegel the Elder. Bruegel's landscapes, with their distant mountain ranges, were known chiefly to his successors through the series of engraved landscapes published by Hieronymus Cock in Antwerp. They were inspired memories of the Alps, with views seen from high ground of rivers meandering across a plain to a far distant coastline. Specific motifs from these prints were used by succeeding generations of artists, including Joos de Momper, Jan Bruegel, and Segers's teacher, Gillis van Coninxloo. From such intermediaries, or directly from

Bruegel's prints, Segers could have absorbed such incidental motifs as broken trees, wooden fences, and clouds that obscure mountain peaks. Joos de Momper displays the same wildness that later characterizes Segers's works, and Segers may also have been influenced by de Momper's linear definition of form and the fluidity of his brushwork. It is interesting to note that Segers's *River Valley* (Plate 46) was attributed to de Momper before the discovery that it had been signed in full by Segers. This painting and *Mountain Valley* at The Hague (Figure I) are both thought to be early works, belonging to the period before 1620. The *Mountain Valley* was subsequently used as a model for an etching, *River Valley with Four Trees* (Plates 50 and 51).

Hendrik Goltzius's influence on Segers was general rather than specific. His fantastic landscapes must have been known to Segers, and could have been an important spur to Segers's own vision. An interesting example of Goltzius's fantasy is an unpublished landscape drawing in the British Museum, executed in pen and brown ink with extraordinary vigor (Figure II). This is thought to be an early drawing, possibly his earliest landscape, comparable in style and in some of its features to a *Pastoral Landscape*, another early drawing by Goltzius, signed and dated 1592, at Chatsworth. But Segers never produced a landscape that could be recognized as an exact quotation from Goltzius or any other artist's work.

16

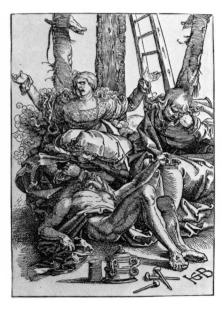

Hans Baldung Grien (1484/5–1545).
Lamentation over the Dead Christ.
Woodcut. 22 x 15.4 cm.
British Museum, London.

An influence on Segers that has only recently been noted by E. Haverkamp Begemann is that of Jacob Pynas, a Dutch follower of Adam Elsheimer, whose *oeuvre* was not clearly defined until now. According to Begemann, Segers took various motifs from Pynas: the road on top of a ridge, the winding road in the foreground that suddenly disappears as the ground falls away, tiny figures walking or riding on horseback on a distant road, and figures partly hidden by rising ground. Segers appears to have absorbed, through Pynas, landscape compositions favored by Elsheimer, especially those which made possible distant views beyond tree-covered valleys. Most frequently, the arrangement adopted consisted of high mountains on one side, trees on the other, and, in between, a valley with trees framing a distant view. Although other Dutch contemporaries of Segers used such views, it does seem likely that Pynas was Segers's source.

Another Northern artist, active in Rome, who apparently influenced Segers was Paul Bril. A print engraved by Simon Frisius, probably after one of Bril's designs, a night landscape (Figure III) published in 1614 in *Topographia Variorum Regionum*, was at the back of Segers's mind when he produced the two versions of his etching *River Valley with a Waterfall* (HB 21 and 22, Plates 23, 24, 25, and 57). These prints seem to be isolated instances among the mountain landscapes of a discernible, though not close, imitation of another artist's work.

Examples of direct copies made by Segers are his two religious prints: *Tobias and the Angel* (Plate 48), after Hendrik Goudt's print (Figure IV), which was in turn after a painting by Adam Elsheimer and the previously noted *Lamentation over the Dead Christ* (HB 2b and 2a, Plates 4 and 49) after a woodcut by Hans Baldung. In both Segers followed the figures of the original, but altered the background. In the first the landscape has been completely changed to accommodate a view over a valley to a distant low horizon. In the second (Figure V), Segers concentrated on the figures, heightening their dramatic impact by omitting the thieves' crosses.

Obviously, Segers's prints of those buildings which were known to him only through the prints or drawings of other artists could also be called copies. A striking example is the *Tomb of the Horatii and Curiatii* (HB 45, Plate 37); however, as Segers habitually rearranged borrowed material, it is not surprising that the source of this view is not immediately recognizable. Segers's print goes back to one attributed to Elsheimer (Figure VI). Specific locations have been identified in two etchings with distant views of towns and villages. They are the *View of Amersfoort* (HB30, Plate 31) and the *View of Wageningen* (HB 31b, Plate 64). The latter print is a close copy of the painting of the same subject (Plate 47).

Segers's mountain landscapes could have been

inspired by other artists, either contemporaries or nearly so, such as Hans Bol, van Valckenborch, van Wieringen, and Roelandt Savery, although no specific evidence exists to which one can point with authority. Joos de Momper and Goltzius from the Netherlands, and Jan Pynas and Paul Bril from Rome, appear to be the main sources on which Segers drew. Yet the motifs that he borrowed are transformed to express a singularly original vision, one which is not, however, "the confession of a tortured soul," as Fraenger would have us believe. When not a record of identifiable Dutch villages, his subjects, while reflecting inherited formulae, are transmuted in the course of his experiments with the medium of etching. The originality of Segers's approach to his art lies far more than has been realized in his treatment of his themes than in the themes themselves. Although it is now possible to trace the sources of some of his fantasies, we still cannot explain that indefinable quality that Segers imparts to his barren wastelands peopled only by the odd figures that underline, rather than diminish, the sense of desolation.

Because Segers's preoccupation with technical matters is so central to any discussion of his work, we must study the extraordinary variety which he has wrung from a comparatively small number of subjects. Although we may look for Segers's precursors on the technical side, as we have done with his subjects, we still find that what he has produced derives entirely from his own artistic personality. On close examination, the prints frequently pose many questions which are difficult to answer, because we cannot with any certainty reconstruct precisely the process by which Segers produced them. Often we can only guess at how it was done.

Of his prints, 183 impressions of fifty-four subjects or variants of subjects survive, which gives us an average of three impressions to each print. But the survival is unevenly spread; in some cases there is a relatively large number of impressions. Of *The Enclosed Valley* (HB 13, Plates 12, 13, 14, and 15), for instance, there are twenty-two in four states. One can quickly appreciate from the variety of the impressions here reproduced, that all of Segers's prints were individual creations. In fact, no two impressions from any one plate are the same.

Careful examination of the impressions makes possible some general observations about Segers's attitude to printmaking. The prints reveal that he was producing them very much for his own satisfaction, often pursuing innovation for its own sake. The means that he used to achieve his effects are frequently much more straightforward than one would suspect at first glance. For instance, it might be supposed that Segers was responsible for the invention of color printing. He did, indeed, print in inks of different colors, but he never used more than one color in each

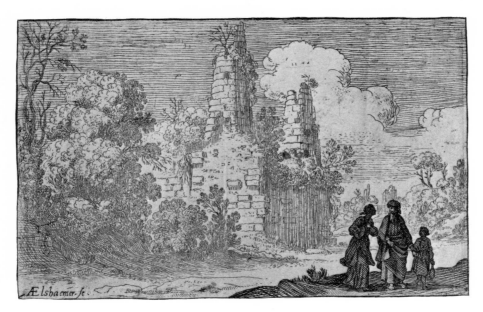

Attributed to Adam Elsheimer
(1578–1610).
**Landscape with the Dismissal of
Hagar.**
Etching. 9.1 x 14.2 cm.
British Museum, London.

impression, and he never used more than one plate for each print. He can be credited with creating the print with the colored line, as opposed to the color-print. But by varying the support, printing on linen or cloth as well as on paper, and covering the surface with color, usually watercolor or bodycolor, before printing, Segers was able to achieve strikingly original results. After printing, he would often retouch the etchings with a brush or even repaint them extensively.

Sometimes Segers used the simple method of making a counterproof, an impression taken from a damp impression instead of the original plate. He then proceeded to work up these counterproofs just like ordinary impressions. Segers also contrived to gain interesting results by cutting down his prints to create new compositions. A good example is the impression at Dresden of the *River Valley with Four Trees* (HB 4, Plate 51), which, in addition to being reworked with drypoint, has been so severely cut down as to make the origin of the resultant composition not immediately recognizable. No doubt Segers gained some inspiration from the different color combinations used in earlier chiaroscuro woodcuts, especially those of Goltzius. These were modelled on the drawings of earlier generations, executed on paper prepared in different colors, examples of which Segers may possibly have seen at some time. He may also have been familiar with drawings by masters of

the Danube School, where the use of prepared paper was customary. It is just possible that his etching, *The Mossy Tree* (HB 32, Plate 32) is a reflection of his fascination with the dark, mysterious woodlands characteristic of the Danube School prints, in which trees are frequently festooned with creepers and mosses. The etched lines are appropriately printed in green but on paper prepared with pink bodycolor, a ground which one does not find in the drawings of Altdorfer and his associates, who were much more partial to various shades of brown and green.

We cannot be sure what may have set off Segers's experimental ideas, but the results are often so surprising that they have deceived the unsuspecting about their true nature. This is especially true of those prints which van Hoogstraeten aptly described as "printed paintings". The counterproof of the *Distant View with a Branch of a Pine Tree* (HB 27 I o, Plate 19) looks like an oil sketch, although it has been printed in dark green on cotton previously colored with light brown watercolor. Segers then overpainted it with yellow and green oil paint, and it is this transformation which so successfully threw some off the scent. Another deceptive work is the heavily overpainted and varnished impression of *The House in the Woods* (HB 35 c, Plate 34), which looks like a small oil.

Most of the methods used by Segers to achieve the effects obtained through regular etching technique are not in

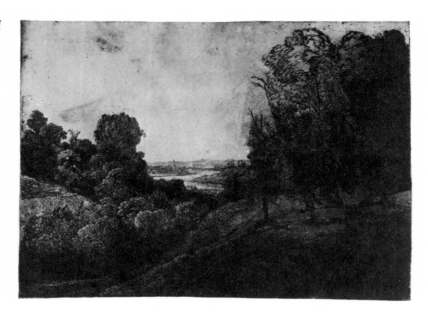

VII

Rembrandt (1606–1669).
The Flight into Egypt.
Etching. 21.3 x 28.4 cm. Hind 266 II
British Museum, London.

themselves strikingly original. They involve the use of drypoint and stopout varnish, and the wiping of areas for tonal effects. Only in one respect, recently analyzed by Haverkamp Begemann, is Segers using a new method. This, known as sugarbite or lift-ground technique, involves the application of the design in ink and sugar with the brush (a mixture that does not dry completely) onto the clean copper plate, which is subsequently covered with the ground. When placed in water, the areas to which ink and sugar have been applied will come away, exposing the copper. Then the plate is bitten as usual. Segers used this method to execute the *Winding River in a Valley* (HB 14 Ia, Plate 55). Similar results were not obtained again until the eighteenth century, when the method was "rediscovered" by Alexander Cozens (before 1746–1786) and Thomas Gainsborough (1727–1788). After that, this technique was not in general use until the modern period.

It is not possible in this Introduction to do more than hint at the great variety of results that Segers achieved in his prints. One can admire the remarkably subtle differences he produced in successive impressions from the same plate by varying the emphasis on different areas with washes of watercolor. The four impressions of *The Enclosed Valley* (HB 13, Plates 12, 13, 14, and 15), reproduced here in color, make this abundantly clear. The reader is provided with a concise, and, it is hoped, accurate description of

each print in the Checklist. There is no better introduction to the enchanted world of Segers's "obsessive" prints, unless, of course, one has the chance to look leisurely at the originals in the Rijksmuseum in Amsterdam or in the British Museum in London.

We have noted the sources of Segers's art. We should now consider what effect Segers's work had on contemporary seventeenth-century artists. Because of the lack of dated works, it is not always easy to see in which direction the influence flowed. Also, it is possible that his contemporaries came to similar solutions quite independent of him and of each other. One wonders, for instance, whether landscapes such as Segers's *Hilly and Wooded Landscape* (Plate 45) and *The Valley* (Plate 41) were an inspiration to an artist like Cornelius Vroom, whose views often have a similar character. Despite that similarity, however, the strange individual atmosphere of disquiet Segers imparts to almost all of his work is not to be found in Vroom or in any other of his contemporaries.

Certainly Rembrandt was the most significant of the younger artists of the day who were greatly impressed by Segers's paintings of barren mountain landscapes. In several of his own dramatic landscapes, like the *Stormy Landscape*, c. 1638, in Brunswick, Rembrandt seems to have caught something of Segers's atmosphere. And this is no doubt a reflection of the younger artist's admiration. Not only did Rembrandt almost certainly own Segers's *Mountain Landscape* (Plate 3), but he also repainted it, on the left,

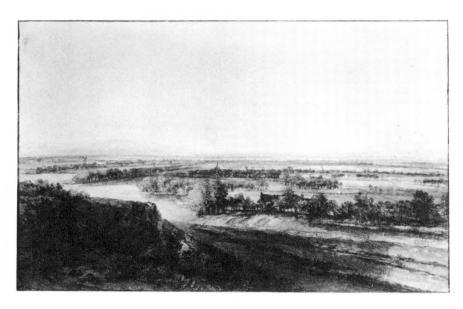

Philips de Koninck (1619–1688).
**View over a Plain with a River and a
Line of Hills in the Distance.**
*Watercolor and bodycolor, heightened with
white. 13.8 x 21 cm.*
British Museum, London.

adding the wagon, its driver and horses, and the man walking alongside. On the right, Rembrandt has heavily painted the great rocks, intensifying the contrast between the light on these and the dark range behind. These additions are all executed with a full brush, and the results contrast strikingly with Segers's customary, much thinner treatment.

 The *Mountain Landscape* is not the only work of Segers that Rembrandt altered. He transformed Segers's etching *Tobias and the Angel* (HB 1b, Plate 48) into *The Flight into Egypt* (Hind, 266, Figure VII). He reworked the right-hand part of the subject completely, making some small changes in the other half. Segers's importance for Rembrandt was considerable, for it seems that Rembrandt was able to gain an inkling from Segers's example of the full potential of the etched line. The influence of Segers's etchings on Rembrandt emerged gradually, becoming clearly discernible in the etchings of the 1640s. For instance, Rembrandt was almost certainly following Segers when he wiped the plate, leaving varying amounts of ink on its surface. Increasingly he produced impressions in which the tonal effects were never the same in successive pulls. Unlike Segers, Rembrandt only very rarely used prepared or tinted paper, but he experimented and achieved comparable results by printing on different papers. Rembrandt adapted the working techniques that he borrowed from Segers to the needs of his more pictorial mode of expression. The younger artist must also have

admired Segers's reworking of the plate to create different states. This adventurous approach to printmaking was taken up enthusiastically by Rembrandt, and given a new significance undreamt of by Segers.

 Rembrandt's admiration for Segers's work communicated itself to one of his followers, Philips de Koninck (1619–1688). We can see Segers's influence reflected in his large painted panoramic landscapes. These views far and wide over a flat plain stretching away to a low distant horizon, seen from an elevated foreground, are of a type he could have taken over from Segers (Figure VIII). It seems, however, that Segers had no other noticeable effect on the Dutch landscape painters.

 Johannes Ruischer, a seventeenth-century graphic artist, is reputed to have been influenced by Segers. In his day, Ruischer was known as the young "Hercules," but in fact his debt to Rembrandt was much more important. Whether or not Ruischer was a pupil of Segers, his spirit was evidently too prosaic to have been fired by Segers's visionary fantasy. With the benefit of hindsight, it seems strange that some of Ruischer's prints were, until very recently, attributed to Segers. With the attribution of these prints to Ruischer, expertly established by E. Trautscholdt, a clear view of the unique quality of Segers's work becomes possible for the first time.

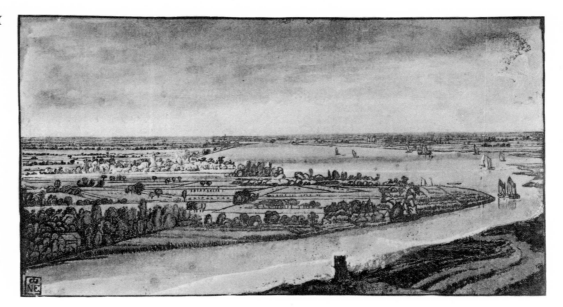

IX

Johannes Ruischer (c. 1625–after 1675).
A River Meandering across a Plain.
Etching, printed in black on grayish paper, entirely overpainted in bodycolor and watercolor. 15.5 x 27.7 cm.
Museum of Fine Art, Budapest.

In only one impression by Ruischer does any association with Segers seem at all possible. This is the etching, *A River Meandering across a Plain* (Trautscholdt, No. 18a, Figure IX), which has been overpainted in watercolor, bodycolor, and oil. We can be reasonably sure that this additional work is by Ruischer himself, because the particular shades of coloring in it match those that occur most frequently in his landscape drawings. While this overpainting may seem somewhat in Segers's manner, its character is quite naturalistic and conveys the impression of intense sunlight illuminating a small patch of distant landscape.

Apart from Rembrandt, de Koninck, and Ruischer, no other seventeenth-century artists seem to have been touched by Segers's genius, and as we have seen, Ruischer was incapable of exploiting the rich technical and expressive resources that Segers had commanded; and in any case, Segers's individuality made imitation hardly possible. To later generations in the second half of the century, Segers's landscapes undoubtedly seemed old-fashioned. Certainly his oil paintings were so regarded, from the evidence of the enlargements noted in the check-list. To realize that his visionary landscapes derive from an artistic tradition does not in any way lessen their magic; rather, it vividly demonstrates that Segers's originality, like that of most other creative geniuses is founded on an imaginative transformation of inherited means and vocabulary.

In conclusion, it is perhaps worth asking what significance Segers's work could have today. His example might well persuade graphic artists and printmakers to consider for a moment the true nature of originality. New ways of doing things have a special fascination for young artists but they can be dangerously seductive. Contemporary prints all too often give the impression that the technicalities of their production were so exacting that the creators had no energy to spare for questions of design, balance, or pattern. Segers gives all artists a wonderful object lesson proving that originality of perception and style can derive from the simplest and most straightforward means. Because of his complete mastery of the chosen means of expression, technique, for Segers, was always the servant, never the master. It is the restriction of theme rather than of vision, which sets apart Segers's unique contribution to European art.

Bibliographical Note

No recent study covers every aspect of Segers's work with equal thoroughness. An excellent account of the artist's paintings, with a discussion of the etchings, is found in Eduard Trautscholdt's article in Thieme-Becker, *Allgemeines Lexicon der bildenden Kunstler,* XXX, 1936, pp. 444–58, which has a complete bibliography up to 1936. The recent publication by Egbert Haverkamp Begemann, *Hercules Segers: The Complete Etchings,* 1973, with a fascinating introduction by Karel G. Boon and a supplement on Segers's supposed follower, Johannes Ruischer by E. Trautscholdt, supersedes all previous studies of the etchings. It consists of a thorough technical and historical study of the prints, as well as a *catalogue raisonné.* It is a work that must be consulted by all who are engrossed in Segers's art.

Readers will find mentioned throughout this book the abbreviation HB, followed by a number that refers to entries in E. Haverkamp Begemann's catalogue. Only in one respect does the new study fail to surpass the important study in three volumes by Jaro Springer, *Die Radierungen des Herkules Seghers,* Berlin, 1910–1912. Sometimes, the facsimile plates leave something to be desired when compared with those of the earlier book. The detailed examination of each impression in the later work, however, is a model of care and precision. Even though I occasionally differ with the plate descriptions, I have turned to the book again and again with profit. The references to Trautscholdt, followed by a number, accord with his list of Segers's paintings in the *Thieme-Becker* article.

A number of other authors have studied Segers's techniques in recent years. Willem van Leusden, a Dutch artist, has proposed solutions to the mystery of Segers's etching methods, according to the results of his own efforts to produce similar effects in his printwork. His conclusions form an interesting though not wholly convincing book, published in English under the title, *The Etchings of Hercules Segers and the Problems of his Graphic Technique,* Utrecht, 1961. In 1967 a major exhibition of Segers's work, and that of his forerunners and associates, was held in the Rijksmuseum, Amsterdam. Unfortunately, the catalogue was printed only in Dutch, but there is an English translation of Karel G. Boon's informative introduction. Professor J. G. van Gelder made some important observations and additions to the still too small group of Segers's paintings in two articles that appeared in *Oud Holland,* LXV, 1950, pp. 216–26; LXVIII, 1953, pp. 144–57.

The most up-to-date account of the artist's life, together with all surviving documentary evidence, is included in E. Haverkamp Begemann's study.

Color Plates

1. Skull
New England, private collection
Oil on linen. 28 x 25.4 cm.

2. River Valley with Houses, Trautscholdt 18
Rotterdam, Boymans-van Beuningen Museum
Oil on canvas. 70 x 86.6 cm.

3. Mountain Landscape, Trautscholdt 12
Florence, Uffizi
Oil on canvas. 55.2 x 99 cm.

Repainted in part by Rembrandt, and most probably the painting by Segers described as "a great landscape" in the 1656 inventory of Rembrandt's property.

4. Lamentation over the Dead Christ, HB 2b
Amsterdam, Rijksmuseum
Etching, printed in blue, on paper colored with watercolor and bodycolor in yellow, green, blue, and purple. 16.2 x 15.9 cm.

A free copy after a woodcut by Hans Baldung Grien (1484/5–1545), the highly original German artist. For an impression of this etching printed in black, see HB 2a, Plate 49.

5. Mountain Valley with Broken Pine Trees, HB 3
London, British Museum
Etching and some drypoint in the lower left-hand corner, printed in black on paper prepared with light brown watercolor. 28 x 41.1 cm.

Related in style and technique to *River Valley with Four Trees* (HB 4; Plates 50 and 51) and *Rocky Mountain Valley with Waterfalls* (HB 5; Plate 52). The only impression known.

6. Mountain Valley with Fenced Fields, HB 6 II d
Amsterdam, Rijksmuseum
Etching and drypoint, printed in blue on white paper; pinkish gray bodycolor or oil paint and blue watercolor added to the sky. 22.5 x 48.9 cm.

Allied in style and technique to *The Enclosed Valley* (HB 13, Plates 12–15).

7. Rocky Valley, at the Right a Man Carrying a Stick, HB 9 II b
Amsterdam, Rijksmuseum
Etching, printed in green on paper with light green bodycolor. 14.3 x 20 cm.

Very close in manner to *Rocky Mountains with Tree Stumps in the Foreground* (HB 8b; Plate 54).

8. Plateau in Rocky Mountains, HB 10 1a
Amsterdam, Rijksmuseum
Etching and drypoint, printed in blue on brownish yellow paper prepared in pink bodycolor. Plate not fully wiped leaving patches of blue, especially in the sky. 13.5 x 18.8 cm.

9. Rocky Valley with Low Clouds, HB 11
Amsterdam, Rijksmuseum
The blurred quality of the impression suggests that this is a counterproof. Etching and drypoint, printed in black on yellowish brown paper prepared with gray bodycolor. Parts of the landscape touched with brownish gray bodycolor. 14.4 x 20.1 cm.

Particularly close in its treatment of details to *Rocky Mountains with Tree Stumps in the Foreground* (Plate 54). The only impression known.

10. Rocky Valley with a Road Leading Into It, HB 12a
Amsterdam, Rijksmuseum
Etching, printed in black on off-white prepared paper, afterwards colored in brown and gray watercolor and light green and white bodycolor. The figures of a man and woman have been added with pen, almost certainly by Segers himself. 23.6 x 28.5 cm.

The following illustration, Plate 11, although cut down, shows what Segers covered by over-painting.

11. Rocky Valley with a Road Leading Into It, HB 12b
Amsterdam, Rijksmuseum
Etching, printed in black. Impression much cut down on all sides. 16.3 x 24.6 cm.

12. The Enclosed Valley, HB 13 I a
Amsterdam, Rijksmuseum
Etching, printed in black on brown cloth dyed gray, with gray wash on clouds, mountains on left and distant background. Light brown wash in the center and right-hand foreground. 10.8 x 19.4 cm.

This etching survives in more impressions than any other by Segers (cf. Plates 13–15).

13. The Enclosed Valley, HB 13 III q
Amsterdam, Rijksmuseum
Etching, after the removal of some drypoint working and the addition of fresh drypoint working in the middle distance and central foreground, printed in blue; then tinted here and there with grayish green, brown, and gray watercolor washes, the latter probably over white bodycolor. The sky has been partly gone over with thin grayish white bodycolor. 11 x 18.5 cm.

14. The Enclosed Valley, HB 13 III p
Amsterdam, Rijksmuseum
Etching, after the removal of some drypoint working and

the addition of fresh in the middle distance and central foreground, printed in brown on light brown prepared paper. Parts of the landscape tinted in brown wash. 10.7 x 18.9 cm.

Marks on the paper suggest that Segers took a counterproof on linen from this impression.

15. The Enclosed Valley, HB 13 III u
Washington, D.C., The National Gallery of Art, Lessing J. Rosenwald Collection
Etching, after the removal of some drypoint working and the addition of fresh in the middle distance and central foreground, printed in brown on paper prepared with light brown bodycolor. 10.8 x 18.7 cm.

In the upper left-hand corner there appear to be accidental pressure marks made by a piece of cloth; and, on the upper edge, a fingerprint, probably the artist's.

16. Rocky Mountains, a Forked Tree on One Side: Version I, HB 15 I a
Amsterdam, Rijksmuseum
Counterproof of the first state of this etching, before the addition of drypoint, printed in black on cloth dyed light brown. 10 x 19.1 cm.

No other impression of the first state is known.

17. Rocky Mountains, a Forked Tree on One Side: Version II, HB 16
Amsterdam, Rijksmuseum
Etching, a negative printing in gray on paper prepared with dark brown bodycolor. Afterwards the landscape painted in various shades of green watercolor and bodycolor. 10.2 x 18 cm.

Formerly thought to have been taken from the same plate as that used to produce Version I of this subject (cf. Plate 16). The only impression known.

18. Mountain Gorge Bordered by a Road: Version I, HB 17 I a
Amsterdam, Rijksmuseum
Counterproof of the first state of this etching, before the addition of drypoint, printed in black on yellowish brown prepared cotton; afterwards partly worked over by Segers with yellow oil paint, and, in the sky, with grayish white paint, partly oxidized. 15.6 x 16.1 cm.

19. Mountain Gorge Bordered by a Road: Version I, HB 17 II b
Amsterdam, Rijksmuseum
Etching, with drypoint added, printed in blue on paper with pink bodycolor with areas shaded in blue watercolor. 16.7 x 15.4 cm.

Here Segers has used a fragment of one of his plates, the *Large Ship*, to produce this print. No

impressions taken before the plate was cut survive. In the upper half of the impression reproduced here we can see part of the rigging of the ship around the bowsprit. For other etchings printed on a fragment of the same plate, see Plates 23, 54. This etching and Plate 18 are similar in detail to *Mountains and Ravines, a Man Walking to the Right: Version I* (Plates 20, 21).

20. Mountains and Ravines, a Man Walking to the Right: Version I, HB 19a
Amsterdam, Rijksmuseum
Etching, printed in blue on paper prepared with pink bodycolor, mounted on linen. The foreground is partly colored in brown and green, the houses on the left touched with red watercolor, and areas in the middle and far distance with gray and brown. The sky and water have been overpainted in bluish white bodycolor. 15.6 x 21 cm.

Very similar in style to *Mountain Gorge Bordered by a Road: Version I* (Plates 18, 19).

21. Mountains and Ravines, a Man Walking to the Right: Version I, HB 19d
Leningrad, Hermitage Museum
Etching, printed in bluish green on paper lightly tinted with pink watercolor. 14.4 x 18.8 cm.

Very similar in style to *Mountain Gorge Bordered by a Road: Version I* (Plates 18, 19).

22. Mountains and Ravines, a Man Walking to the Right: Version II, HB 20
Berlin, Staatliche Museen
Etching, printed in off-white on brown paper prepared with black bodycolor. In some areas the brown paper can be seen. 15.4 x 20.5 cm.

Not, as was formerly thought, from the same plate as Plate 21. The only impression known.

23. River Valley with a Waterfall: Version I, HB 21 III d
Amsterdam, Rijksmuseum
Etching, with some reworking in drypoint after partial burnishing out of previous work, printed in blue on yellow paper, prepared with bluish gray bodycolor. 14.3 x 19.2 cm.

Printed on a fragment of the plate of Segers's *Large Ship*, an etching of which no complete impression survives. In the upper half of this impression we can make out part of the upper rigging of the ship of Plates 19, 54. The print has been varnished.

24. River Valley with a Waterfall: Version II, HB 22 Ia
Amsterdam, Rijksmuseum
Etching, printed in dark green on paper prepared with pink bodycolor, and then varnished. 15.2 x 18.9 cm.

In this proof we can see in the sky signs of the use of a porous ground. The round area in the center has been left uncovered in the process of printing.

25. River Valley with a Waterfall: Version II, HB 22 II e
Amsterdam, Rijksmuseum
Etching, printed in black on paper prepared with blue watercolor. 14.8 x 19.3 cm.

This impression is an example of the print's second state, in which the landscape has been lightly burnished and the plate rebitten so that the etched lines are thicker.

26. Road Skirting a Plateau, a River in the Distance, HB 25 I b
Amsterdam, Rijksmuseum
Etching, printed in black on paper prepared with dark blue watercolor, and afterwards heightened with yellow bodycolor. 14.4 x 10.5 cm.

Possibly the plate was etched twice to obtain lines of varying thickness.

27. Distant View with the Branch of a Pine Tree, HB 27 I c
Amsterdam, Rijksmuseum
Etching, printed in dark blue on off-white prepared cloth, colored with brown, green, and blue watercolor, and white wash in the sky along the horizon. 14.3 x 19.5 cm.

28. Distant View with the Branch of a Pine Tree, HB 27 III s
Paris, Bibliothèque Nationale
Etching, with some reworking in drypoint, printed in dark green on paper colored in light green; then overpainted in different shades of green, with some purple in the sky.
13.6 x 18.3 cm.

29. Distant View with the Branch of a Pine Tree, HB 27 I o
Amsterdam, Rijksmuseum
Counterproof of an impression of the first state, before the addition of drypoint, printed in dark green on yellowish brown dyed cotton; then worked over in yellow, green, and creamy white oil paint, with touches of blue on the horizon. 14.9 x 19.8 cm.

30. Valley with Towns, Churches and Other Buildings, HB 29 h
London, British Museum
Etching with some drypoint, printed in green on yellow paper, with some areas of red watercolor; overpainted with green bodycolor. 20.4 x 33 cm.

31. View of Amersfoort, HB 30
Amsterdam, Rijksmuseum
Etching and drypoint, printed in blue on brown paper prepared with light green bodycolor in a variety of shades. 8.6 x 30.1 cm.

The recent identification of the town as Amersfoort, formerly thought to be Rhenen, seems to be preferable if one compares it to similar views of Amersfoort, such as the painting by Albert Cuyp in the Museum of Wuppertal-Elberfeld, West Germany (reproduced in W. Stechow, *Dutch Landscape Painting of the Seventeenth Century,* 1966, Fig. 65). The only impression known.

32. The Mossy Tree, HB 32
Amsterdam, Rijksmuseum
Etching, possibly printed by the lift-ground technique in green and greenish black on paper prepared with light pink bodycolor, with the addition of a band of blue and bluish gray bodycolor at the top and bottom. The blue at the top has been partly darkened by oxidation. 16.9 x 9.8 cm.

The subject could well have been inspired by artists of the Danube School, who were active a hundred years earlier. Their prints would have been known to Segers. The only impression known.

33. The Two Trees, HB 33
Amsterdam, Rijksmuseum
Etching, printed in dark brown on pink prepared paper, partly overpainted with blue bodycolor. Here and there are touches of yellow bodycolor on the trees, more especially on the left-hand one. 15.5 x 17.3 cm.

The subject is most unusual for a print. The only impression known.

34. The House in the Woods, HB 35 c
London, British Museum
Etching, printed in black on coarse gray cloth, then overpainted with green watercolor, heightened with yellow oil paint, and varnished. 15.3 x 9.6 cm.

35. The Entrance Gate of 'Kasteel Brederode,' HB 40
Amsterdam, Rijksmuseum
Etching, printed in black on cloth prepared with gray watercolor, then colored with gray watercolor, heightened with white and yellow bodycolor, and some changes made to the building in the background with yellowish white wash. 18.5 x 12.3 cm.

The subject is represented accurately, but in reverse. The only impression known.

36. View from a Window of Segers's House,
HB 41
Amsterdam, Rijksmuseum
Etching, printed in dark gray on cloth prepared with light
green watercolor. 14.1 x 17.7 cm.

For the question of the dating of this print on the basis of the completion of the Noordenkerk, the church seen through the window, see the Introduction, p. 14. The houses in the foreground also appear in one of Segers's paintings (cf. Plate 2). The only impression known.

37. The Tomb of the Horatii and Curiatii,
HB 45
Amsterdam, Rijksmuseum
Etching, printed in black on paper. The sky has been
over-painted with blue oil paint. 12.8 x 19.5 cm.

The subject of this print has only recently been identified by Miss An Zwollo as the tomb of these Roman families in the Roman Campagna between Albano and Ariccia. It seems most probable that Segers based his print on the background of an engraving attributed to Adam Elsheimer, *Landscape with the Dismissal of Hagar* (Fig. VI). The only impression known.

38. Ruins of the Abbey of Rijnsburg:
Large Version, HB 46 a
Amsterdam, Rijksmuseum
Etching, printed in yellow on black prepared paper,
overpainted in red and greenish blue oil paint, then
varnished. 19.3 x 31.5 cm.

The hall of the monastic ruins at Rijnsburg, the last traces of which disappeared at the beginning of the nineteenth century. Both this and the following, less detailed, representation (Plate 39) may well have been based on the same design, probably a drawing by the artist himself.

39. Ruins of the Abbey of Rijnsburg:
Small Version, HB 47 I a
Amsterdam, Rijksmuseum
Etching, before the addition of work in drypoint, printed in
black on cloth dyed light gray, then tinted with yellow,
gray and grayish blue washes. 9.7 x 17.5 cm.

These ruins were represented earlier in a print of 1616 by Jan van de Velde.

40. Ship in a Storm, HB 48
Amsterdam, Rijksmuseum
Etching, printed in light yellow on paper prepared with
brown wash. 10.2 x 17 cm.

Technically close to the *Ruins of the Abbey of Rijnsburg: Large Version* (Plate 38) The only impression known.

Black and White Plates

41. The Valley
Rotterdam, Boymans-van Beuningen Museum
Oil on canvas, mounted on panel. 29.2 x 54.6 cm.
Signed by the artist, "Hercules Segers."

This painting, its true identity undetected, passed through the London salerooms of Messrs. Sotheby, who attributed it to "de Vos," on 9 May 1951. It is more than likely that further unknown paintings by Segers will make their appearance from time to time. According to J. G. van Gelder (*Oud-Holland*, LXVIII, 1953, pp. 154–7), the artist did not paint this with the expectation of subsequently reproducing it as an etching, as is the case with several other paintings, e.g., Segers's *The Two Windmills* (Plate 47). Van Gelder dates the present painting after 1630, perhaps between 1631 and 1632, when the artist was living in The Hague.

The interesting circular building also appears in an earlier painting, recently the subject of a detailed discussion by E. Trautscholdt (*Pantheon*, XXX, 1972, pp. 144 ff), and in the *Large Tree* (Plate 65).

42. Brussels Seen from the Northeast,
Trautscholdt 3
Cologne, Wallraf-Richartz Museum
Oil on oak panel. 24.5 x 39 cm.
This is probably identifiable with a painting

that was in Rembrandt's possession and appeared in the artist's inventory in 1656. At the sale of Rembrandt's property, a painted view of Brussels by Segers was acquired by the marine painter Jan van de Capelle.

43. Village by a River, Trautscholdt 10
Berlin, Staatliche Museen, Gemäldegalerie
Oil on panel. 26 x 36.1 cm. (original size, 12.8 x 36.1 cm.)

This painting, and two others (Plates 44, 47), were each painted by two different artists. Each painting consists of two panels; the lower by Segers, the upper added later by another artist. Van Gelder, who was the first to discuss this (cf. *Oud-Holland*, LXV, 1953, pp. 220–3, 226), has plausibly suggested that they were enlarged to suit the change in taste in the second half of the seventeenth century, by a dealer, probably Johann de Renialme, who at one time had a group of Segers's paintings in his possession.

44. View of Rhenen, Trautscholdt 2
Berlin, Staatliche Museen, Gemäldegalerie
Oil on panel. 42 x 66.6 (original size, 22 x 66.6 cm.)
Signed by the artist. For a comment on this painting, see note on the preceding illustration.

45. Hilly and Wooded Landscape
London, Edward Speelman, Ltd.
Oil on canvas mounted on panel. 36.4 x 53.9 cm.

This painting, which formerly belonged to the New York Historical Society, was first attributed to Hercules Segers in 1958 by E. Haverkamp Begemann in his doctoral thesis, although W. Stechow had earlier attributed it to an artist in Segers's immediate circle. The figures in the right foreground were revealed recently when the painting was cleaned.

46. River Valley, Trautscholdt 1
Amsterdam, Rijksmuseum
Oil on oak panel. 30 x 53.5 cm.
Signed by the artist, "hercules Segers."

47. The Two Windmills
England, private collection
Oil on panel. 27.2 x 36.2 (original size, 13.3 x 36.2 cm.)
The small town represented in this painting is Wageningen. Segers subsequently copied it in reverse in an etching (Plate 64). See the note on Plate 43.

48. Tobias and the Angel, HB 1b
Paris, Musée du Louvre, Cabinet d'Estampes
Edmond de Rothschild

Etching, printed in dark green on white paper. In the sky, the plate has not been completely wiped clean.
20.7 x 28 cm.

This print is a free copy after an engraving by Hendrik Goudt, which reproduces a painting, evidently now lost, by Adam Elsheimer, a German artist who had recently died in 1610. The best painted version is at Copenhagen. The plate was subsequently acquired by Rembrandt, who reworked it, changing the subject to a *Flight into Egypt* (Figure VII). In his transformation of the etching, Rembrandt burnished out the righthand half of the plate, added the Holy Family, and brought forward the river in the background. In later states Rembrandt made further adjustments.

Segers's print is technically related to his *Lamentation over the Dead Christ* after Baldung, (Plates 4, 49) and his *View from a Window of Segers's House* (Plate 36).

49. Lamentation over the Dead Christ, HB 2a
Amsterdam, Rijksmuseum
Etching, printed in black on off-white paper. 16.4 x 15.7 cm.

A free copy in reverse of the figures in the woodcut of this subject by Hans Baldung. For a color reproduction of another impression of this print, see Plate 4. The *View from a Window of Segers's House* (Plate 36), and *Tobias and the Angel* (Plate 48)

are very similar in technique.

50. River Valley with Four Trees, HB 4 I b
London, British Museum
Etching, before the addition of work in drypoint, printed in black on white paper. The marks in the sky and on the left were caused by the plate not being adequately polished. 28.6 x 47.3 cm.

Segers evidently based this print on his own painting, formerly in the collection of Mrs. E. Kessler-Stoop, and now in the Mauritshuis, The Hague (Fig. I). In the print, the subject is reversed. According to E. Haverkamp Begemann, the painting is a fairly early work (before 1620), and the print made soon after.

51. River Valley with Four Trees, HB 4 II c
Dresden, Kupferstich-Kabinett
Etching, with drypoint added in many areas, printed in blue on paper prepared with bluish bodycolor. 15 x 23.5 cm.

The print has been severely cut down, especially on the left, where almost half the subject is missing. No doubt this was done intentionally by the artist to create a new composition.

52. Rocky Mountain Valley with Waterfalls, HB 5
London, British Museum

Etching, printed in grayish blue on white paper. 28.4 x 50.7 cm.

This beautiful unique impression is particularly close in style and technique to the *River Valley with Four Trees* (Plates 50, 51).

53. Mountain Valley with Fenced Fields, HB 6 I b
London, British Museum
Etching, before the addition of work in drypoint, printed in black on white paper, and evidently etched twice. 28.6 x 47.3 cm.

An impression ("maculature") taken to clean the plate, printed on the reverse of Plate 50.

54. Rocky Mountain Valley with Tree Stumps in the Foreground, HB 8b
London, British Museum
Etching and drypoint, printed in dark blue on yellowish brown paper, with parts of the sky and adjacent landscape in bluish gray bodycolor. Other areas are colored in greenish yellow watercolor, which changes to dark green when painted over the blue etched lines. 13 x 19.4 cm.

Printed from a fragment of the plate of the *Large Ship*, an etching by Segers. No impressions taken before the *Large Ship* plate was cut up survive. In the upper right-hand corner of this impression one can make out the uppermost rigging at the top of one of

Hercules Segers (1589/90–after 1633).
Landscape with Rocky Crags.
Brush drawing in dark gray, yellow and green bodycolor, the sky colored in the same gray bodycolor as is frequently used in the prints. 9.9 x 13 cm.
Rijksmuseum, Amsterdam.

the masts, probably the aft. For other fragments, see Plates 19, 23.

55. Winding River in a Valley, HB 14 I a
Amsterdam, Rijksmuseum
Etching, before the addition of work in drypoint, most probably executed entirely by the lift-ground technique, and printed in black on white paper. (See the Introduction for a brief description of this process.) 17.6 x 21.7 cm.

Technically and stylistically akin to prints reproduced as Plates 58, 59, 62, 68, 69. Some features of the landscape recall Segers's painting *Mountain Landscape* (Plate 3).

**56. Mountain Gorge Bordered by a Road:
Version II**, HB 18
Amsterdam, Rijksmuseum
Etching, printed in grayish blue on paper prepared with gray bodycolor. 15.8 x 13.8 cm.

The features of the center of this print recall those of the *Mountain Gorge Bordered by a Road: Version I*. Technically close to *Rocky Valley with a Road Leading Into It* and *Tobias and the Angel* (Plates 10, 11, 48). The only impression known.

**57. River Valley with a Waterfall:
Version II**, HB 22 II g
London, British Museum

Etching, after the light burnishing of the landscape, printed in blue on white paper, subsequently colored with gray wash, probably by a later hand. 15.6 x 18.8 cm.

In the sky, Segers left the plate inadequately covered by the ground; one such area, almost circular in shape, is in the center of it.

**58. Steep Cliffs Bordering a River Valley:
Version I**, HB 23 I a
London, British Museum
Etching, printed in gray on white paper. 9.9 x 13.4 cm.

Very similar in style to *A Road Bordered by Trees with a Town in the Distance* (Plate 62).

In the Rijksmuseum, Amsterdam, there is a drawing based on this print (Figure X), executed in watercolor and bodycolor, and almost identical in size (9.9 x 13 cm). It is very close, not only in the coloring, but also in the rendering of details, to the *River Valley*, a painting signed by the artist (Plate 46). Although the drawing is in the same direction as the etching, rather than in reverse, as it would probably be if it were a preliminary study for it, a comparison with this painting strongly suggests that Segers is its author.

**59. Steep Cliffs Bordering a River Valley:
Version I**, HB 23 II f
Amsterdam, Rijksmuseum

A counterproof, after the addition of extra strengthening of the etching, printed in black on gray prepared paper. 9.3 x 13 cm.

See the comment on the preceding illustration.

60. Steep Cliffs Bordering a River Valley, HB 24a
Amsterdam, Rijksmuseum
Etching, printed in grayish green on white paper, 12.3 x 17.1 cm.

This print has technically much in common with *Ruins of a Monastery* (Plate 70).

**61. A Road Skirting a Plateau with a River
in the Distance**, HB 25 I a
Amsterdam, Rijksmuseum
Etching, before the addition of crosshatching for the shadows, printed in black on white paper. 13.9 x 10.7 cm.

It is possible that Segers may have etched the plate twice, as some of the lines are thinly, some deeply, etched.

**62. A Road Bordered by Trees with a Town
in the Distance**, HB 26a
Amsterdam, Rijksmuseum
Etching, printed in black on white paper. 14.1 x 10.5 cm.

The town appears to be a freely adapted representation of Amersfoort (Plate 31) in an imaginary landscape.

XI

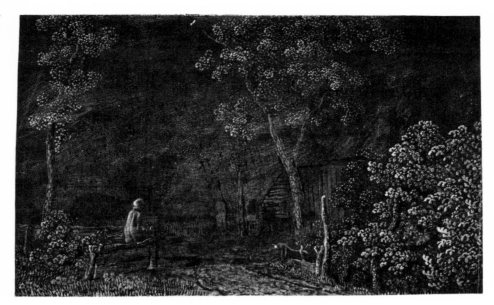

Hercules Segers. (1589/90–after 1633)
Farm Building in a Country Lane.
Brush drawing in yellow and gray body-color over a drawing in black chalk on gray prepared paper. 17.6 x 29.1 cm.
Rijksmuseum, Amsterdam.

63. An Old Oak Tree with a Distant View, HB 28b

Amsterdam, Rijksmuseum
Etching, printed in black on cotton dyed light brown. 7.5 x 13.4 cm.

Apart from the oak tree, the composition of the landscape, if reversed, has much in common with that of the painting, *The Valley* (Plate 41).

64. View of Wageningen, HB 31b

Berlin, Staatliche Museen, Kupferstichkabinett
Etching, printed in blue on white paper, overpainted in light green bodycolor, and then colored with brown and green washes. 9.1 x 31.3 cm.

This print represents in reverse the painting *The Two Windmills* (Plate 47).

65. The Large Tree, HB 34a

Amsterdam, Rijksmuseum
Etching, printed in black on white paper tinted with grayish brown. 21.7 x 27.7 cm.

This print was most probably produced by some variation of the lift-ground technique, the precise details of which are a matter for speculation. It is worth noting that a drawing at Amsterdam, whose attribution to Segers seems convincing, in-volves the search for a somewhat similar effect. This drawing, *Farm Building in a Country Lane* (Figure XI), is executed with a brush in black and yellow body-color on gray prepared paper. (17.6 x 29.1 cm.).

66. The House in the Woods, HB 35b

London, British Museum
Etching, printed in black on light brown dyed cotton. 10.6 x 9.4 cm.

Very close in style and technique to the prints reproduced in Plates 35, 39, 63, 74A and B.

67. A Country Road with Trees and Buildings HB 37

London, British Museum
Etching and drypoint, printed in black on yellowish brown paper. 23 x 27.5 cm.

Somewhat similar in composition to a drawing, attributed to Segers, in the Rijksmuseum (Figure XI). The only impression known.

68. A Castle with Tall Towers, HB 38

Amsterdam, Rijksmuseum
Etching, probably with use of the lift-ground technique, printed in black on paper prepared with light gray bodycolor, and afterwards the shadows added in gray wash. 9.8 x 13.2 cm.

Technically very similar to the following etch-ing (Plate 69). The only impression known.

69. Ruins of 'Kasteel Brederode', HB 39

Amsterdam, Rijksmuseum
Etching, probably with use of the lift-ground technique, printed in black on white paper, partly discolored with brown stains. 10 x 13.5 cm.

Possibly it represents the same gate as that in *The Entrance Gate of 'Kasteel Brederode'* (Plate 35), but seen from the other side. The only impression known.

70. Ruins of a Monastery, HB 44a

London, British Museum
Etching, probably executed by the lift-ground technique, printed in black on white paper. Trial crosshatching in drypoint in the sky. 13.8 x 21 cm.

Work on the plate was evidently not com-pleted.

71. Ruins of the Abbey of Rijnsburg: Large Version, HB 46c

London, British Museum
Etching, printed in yellowish white on dark brown prepared paper. 20.1 x 31.8 cm.

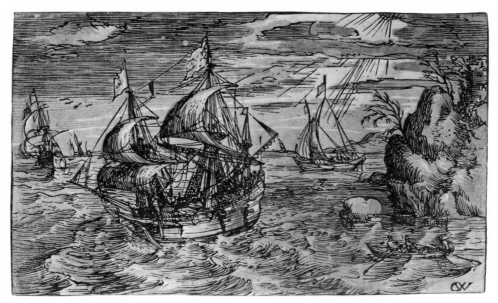

Hendrik Goltzius (1558–1617), after Cornelis Claesz Van Wieringen (1580–1633).
Shipping by a Rocky Coast.
Woodcut. 13.5 x 21.5 cm. Signed with Van Wieringen's monogram.
British Museum, London.

72A. The Small Ships (the left-hand half), HB 50b
Dresden, Kupferstich-Kabinett
Etching, printed in dark gray on paper prepared with greenish gray bodycolor; the ships and their shadows afterwards painted gray. 8.2 x 20.8 cm.

This and the following print are the only surviving fragments of a plate at least 30 cm. wide. They overlap in the middle of the subject. Two of the ships here are copied from a woodcut by Hendrik Goltzius, after Cornelis Claesz van Wieringen, *Shipping by a Rocky Coast* (Figure XII). From this woodcut Segers has also taken the small boat in the foreground on the left and the large ship on the extreme right. The large ship appears again in the left foreground of the second fragment (Plate 72B).

72B. The Small Ships (the right-hand half), HB 50a
Amsterdam, Rijksmuseum
Etching, printed in dark gray on paper prepared with greenish gray bodycolor; the ships and their shadows afterwards painted gray. 7.6 x 14.8 cm.

See note on the preceding illustration.

73. The Large Ships, HB 51
Dresden, Kupferstich-Kabinett
Etching, printed in brown on yellowish paper. 15.5 x 23.4 cm.

The technical handling speaks strongly in favor of Segers's authorship, although E. Haverkamp Begemann entertains some doubts because of the lack of precision in the details of this print. The only impression known.

74A. A Rearing Horse, HB 52
Amsterdam, Rijksmuseum
Etching, printed in black on gray dyed cloth. 10.5 x 7.6 cm.

There are many late sixteenth-century prints which Segers might have used as a model for this etching. We have not, however, been able to trace its exact source. The only impression known.

74B. A Skull, HB 53
Amsterdam, Rijksmuseum
Etching, printed in black on gray dyed cotton. 7.4 x 10.6 cm.

A skull represented in isolation is an unusual subject for a print, skulls usually figured alongside hourglasses in allegorical still-lifes on the theme of worldly vanity There is the same air of detachment in the print as in Segers's painting of a skull (Plate 1). The only impression known.

75. Books, HB 54a
Amsterdam, Rijksmuseum
Etching, printed in green on off-white dyed cotton, colored with gray and black washes. 9.3 x 20.5 cm.

Color Plates

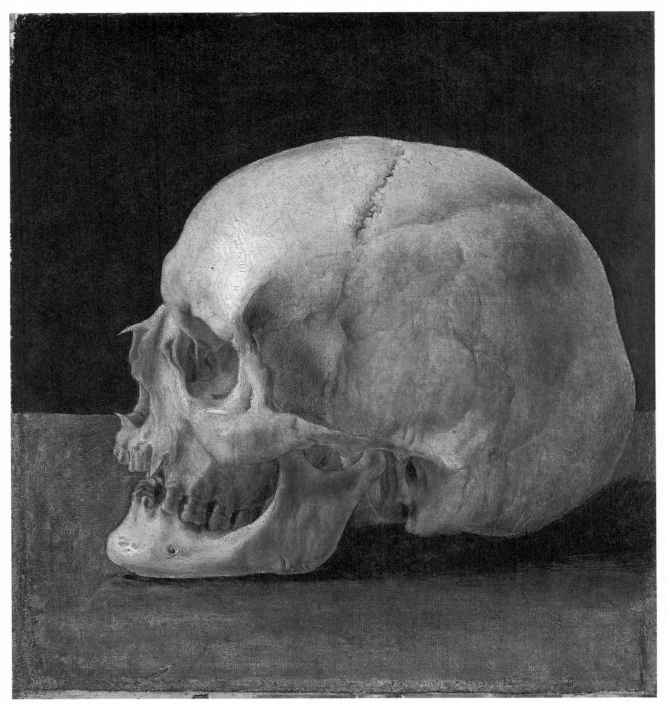

1

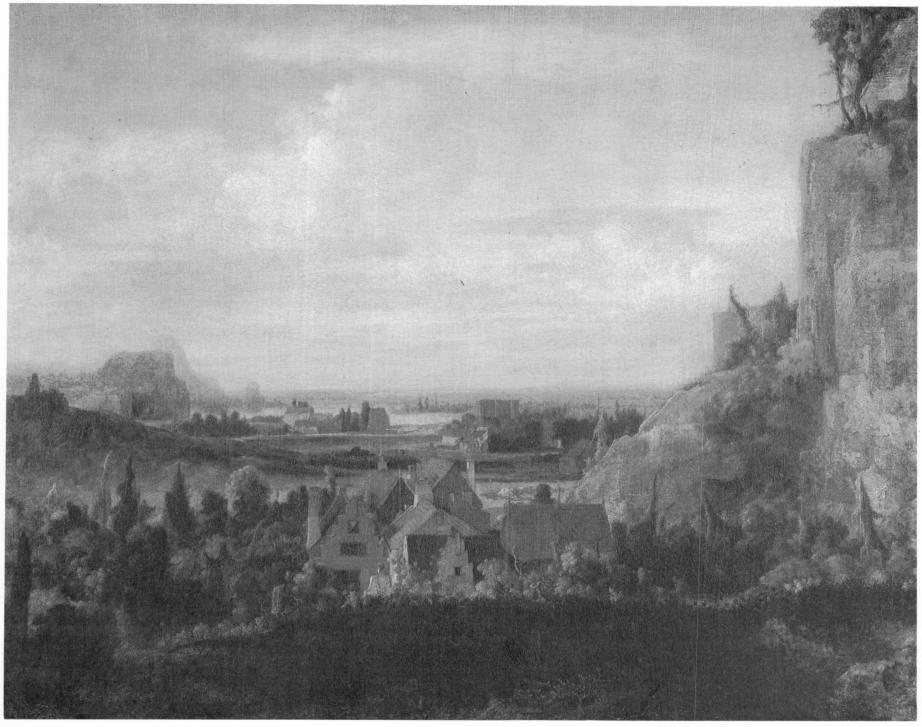

2

3

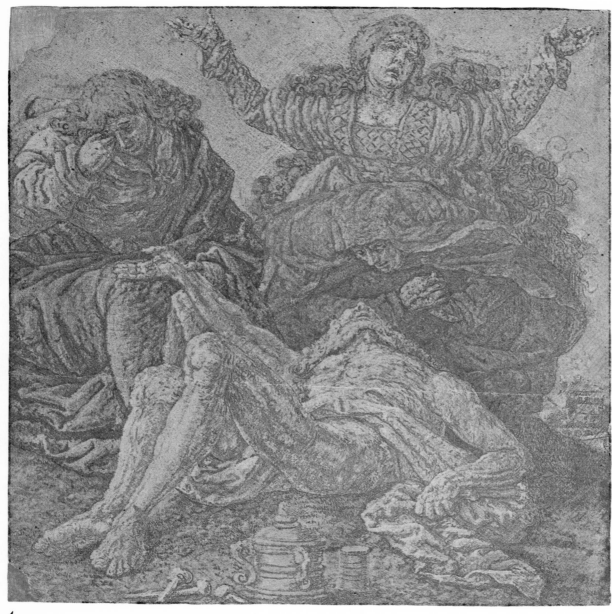

4

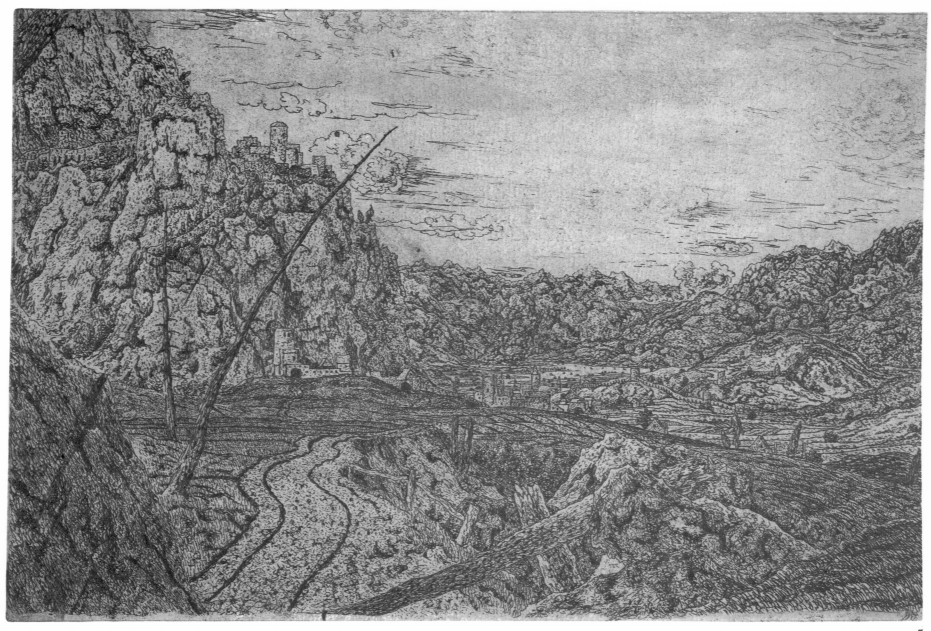

5

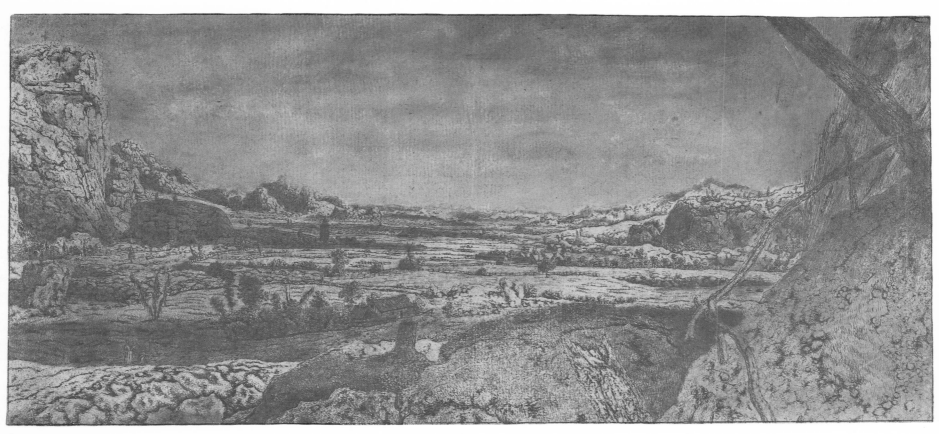

6

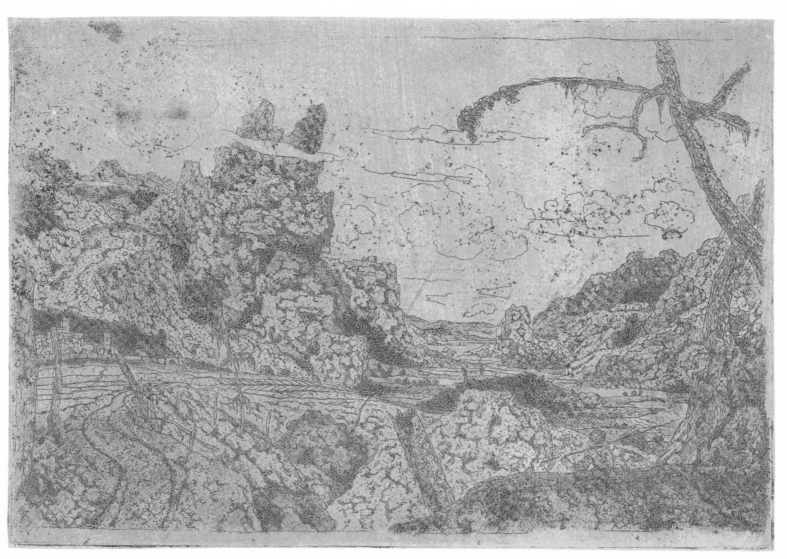

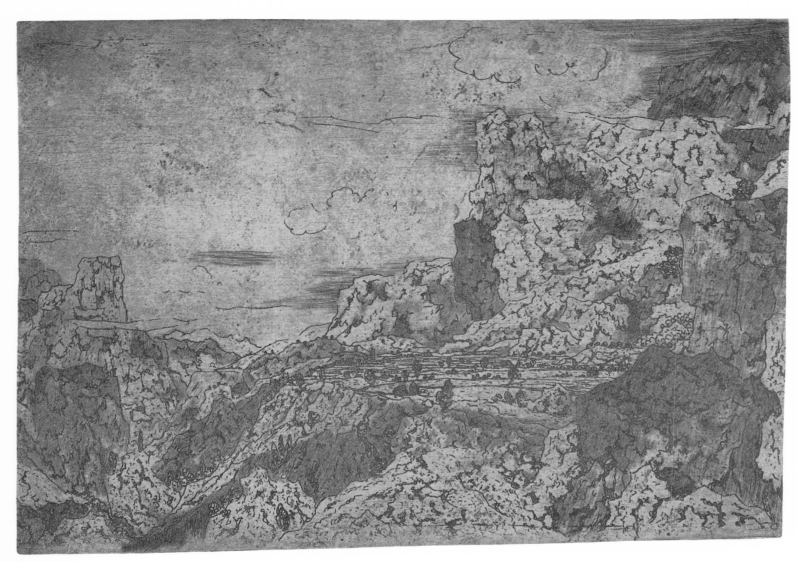

8

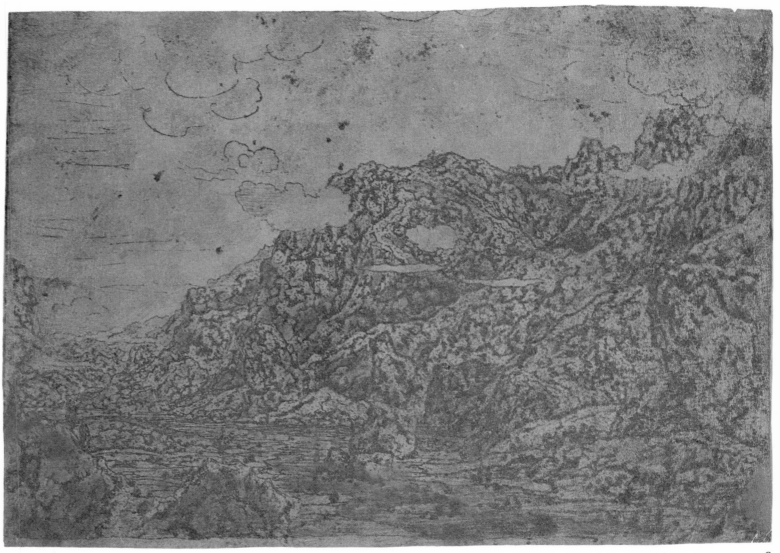

9

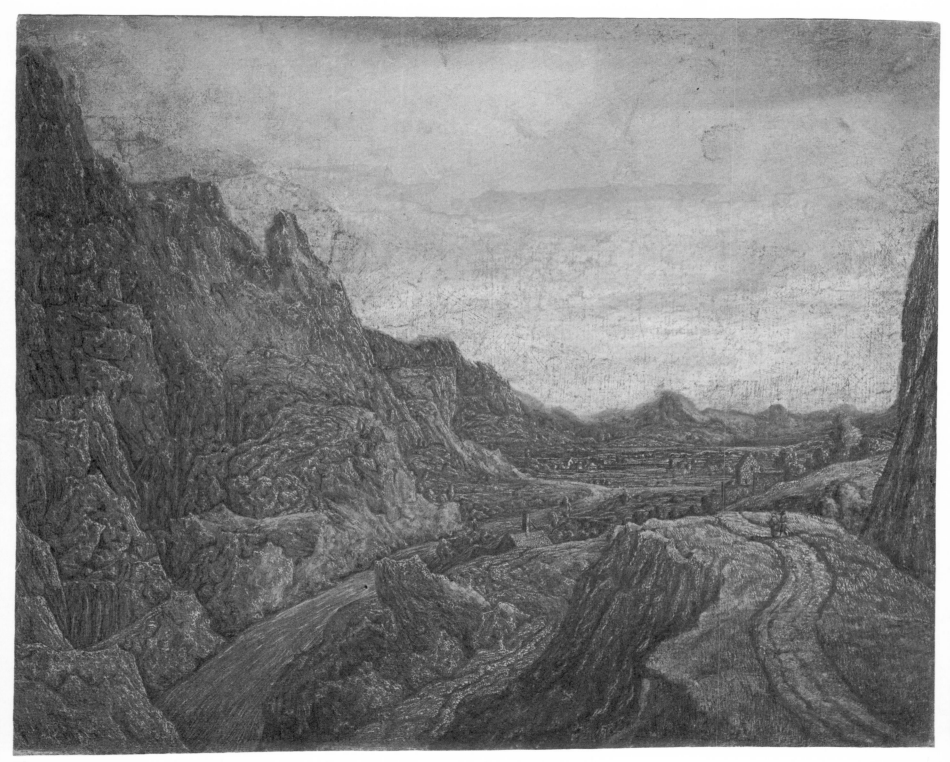

10

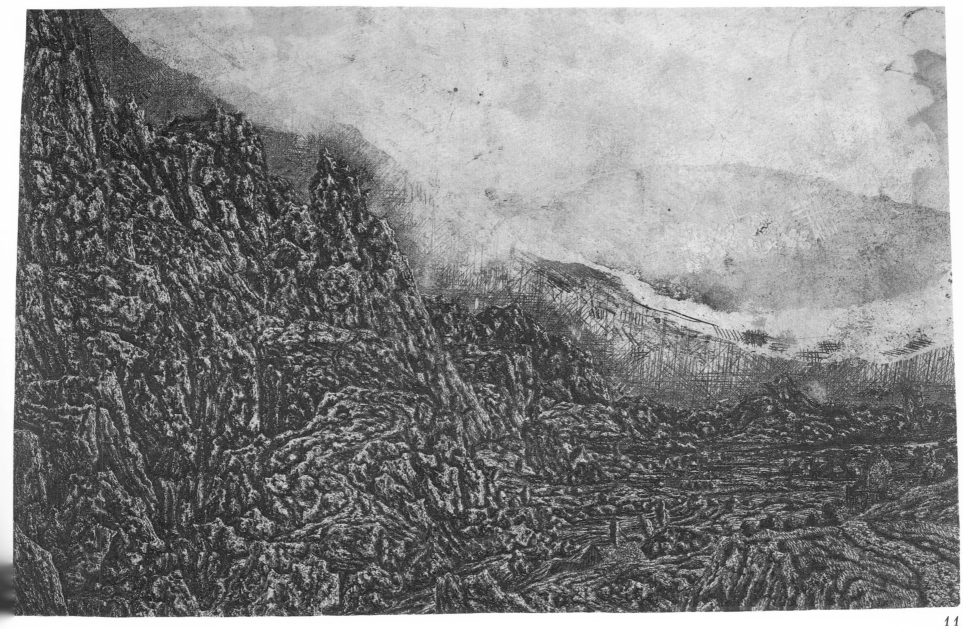

11

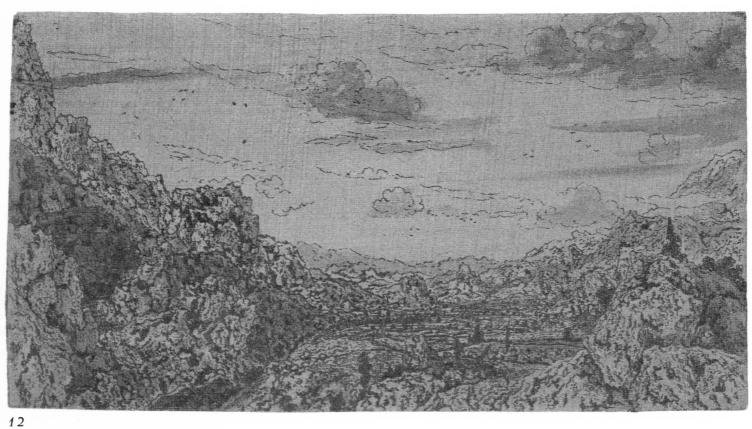

12

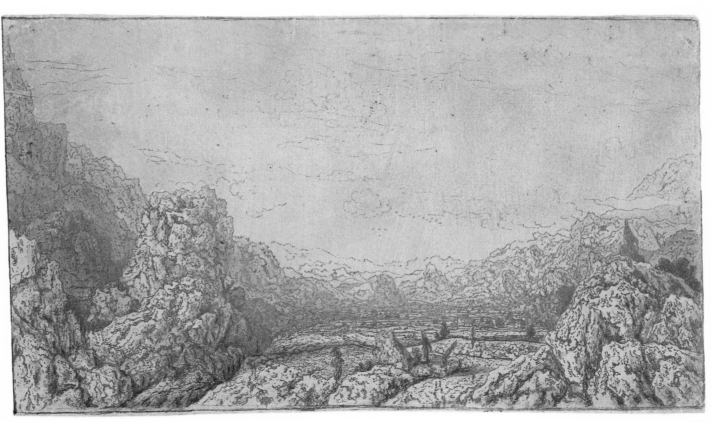

13

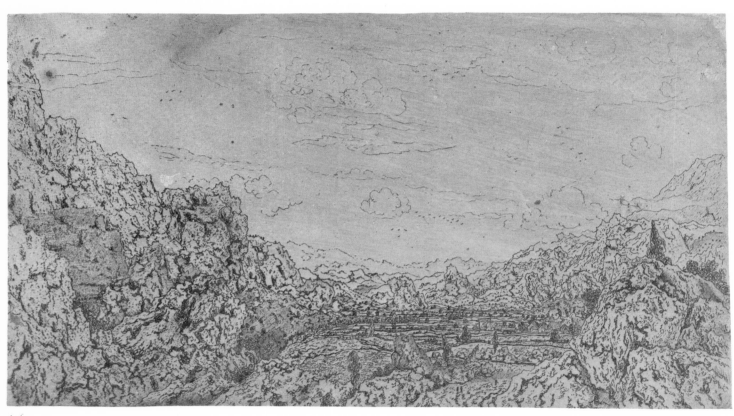

14

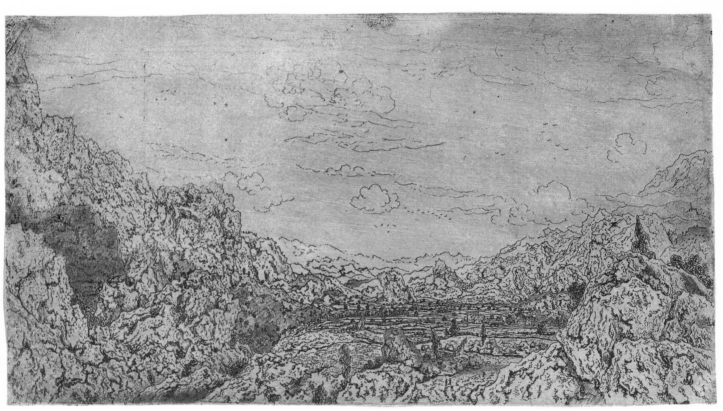

15

16

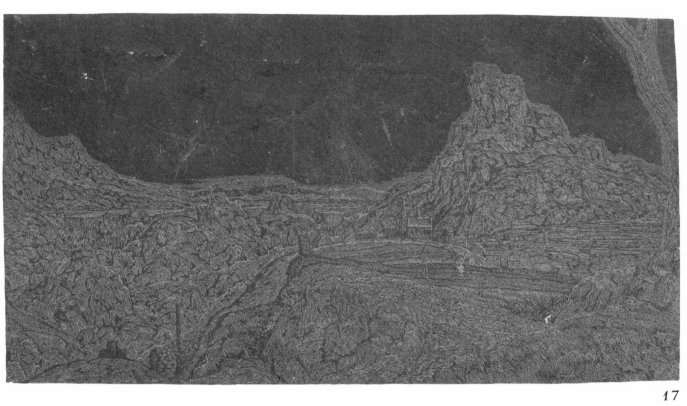

17

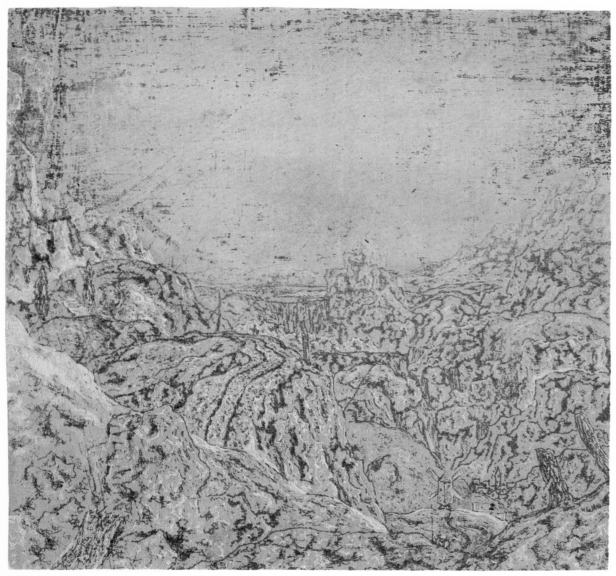

18

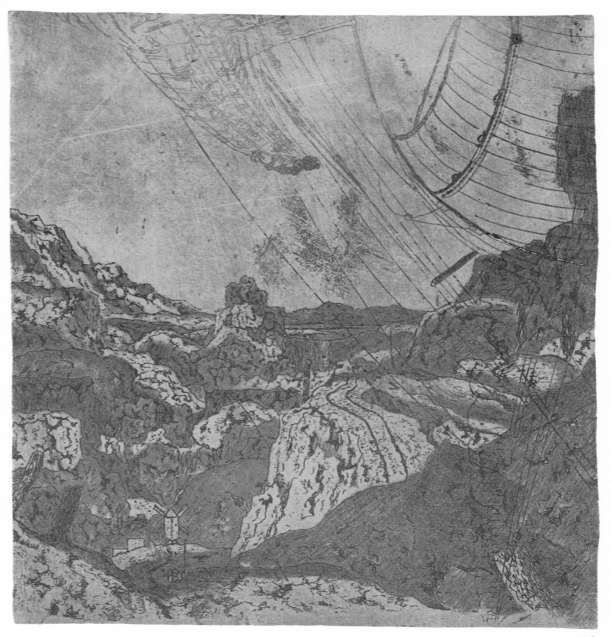

19

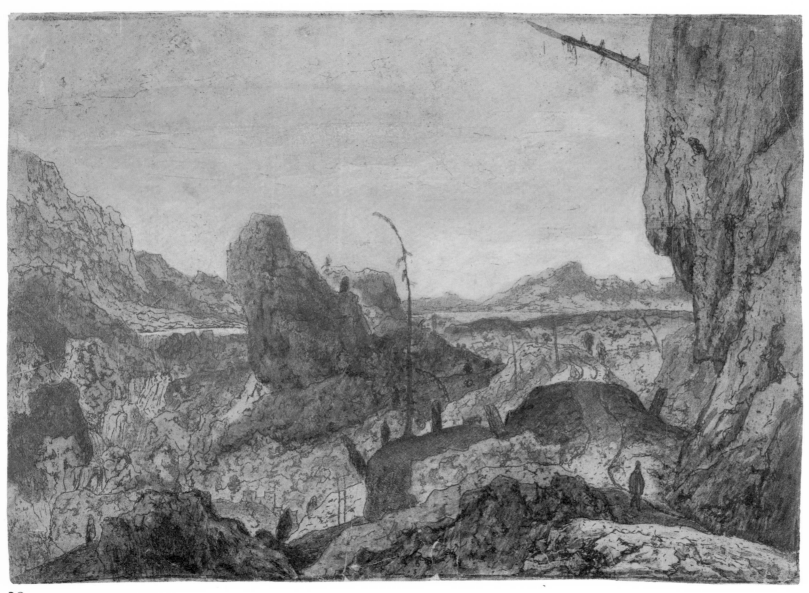

20

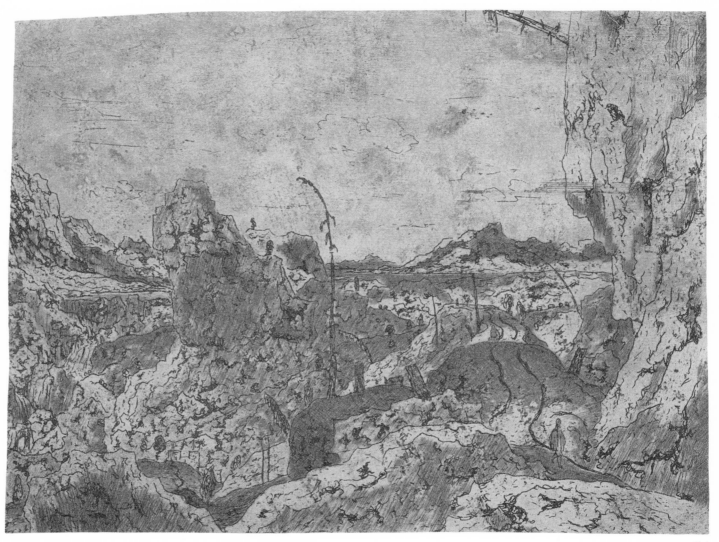

21

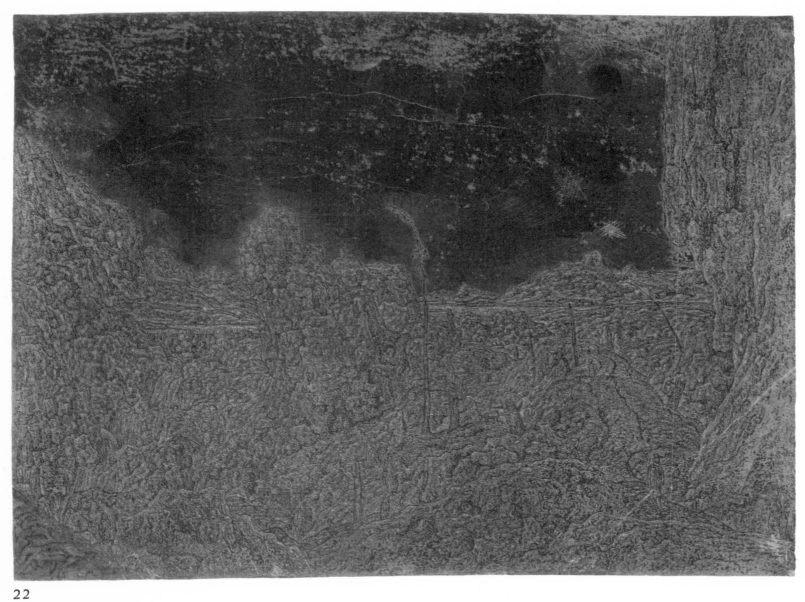

22

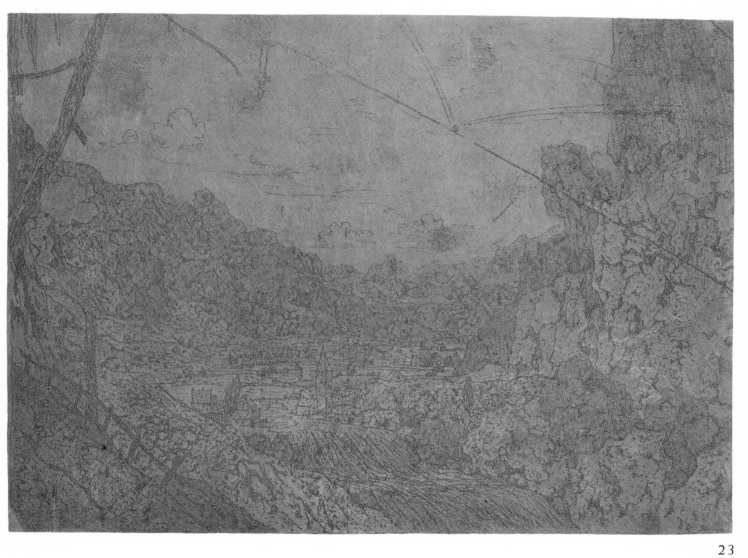

23

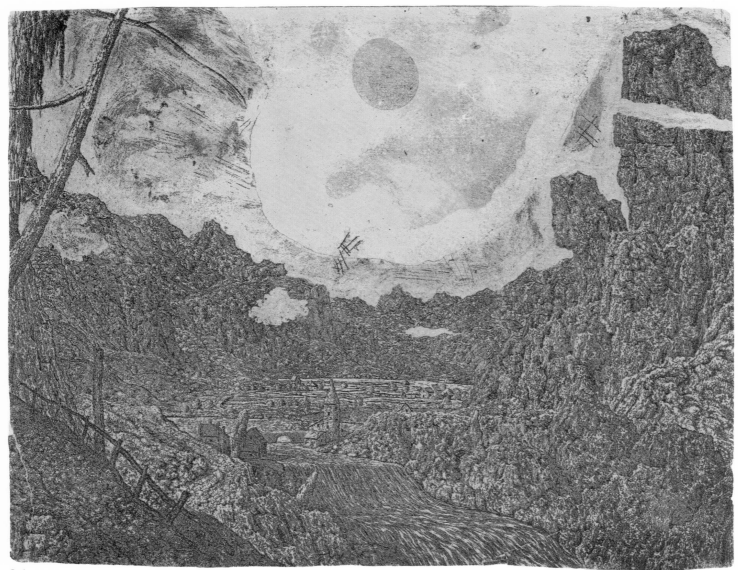

24

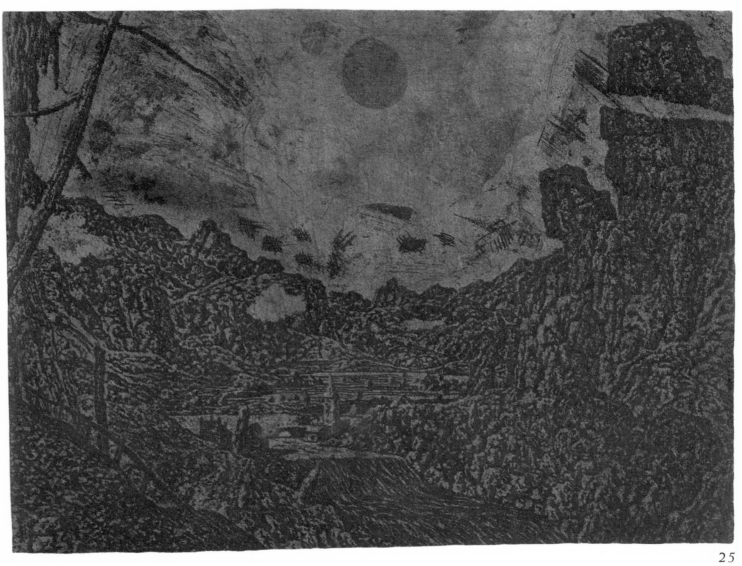

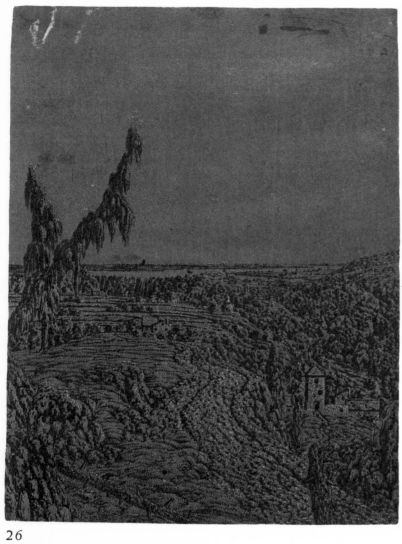

26

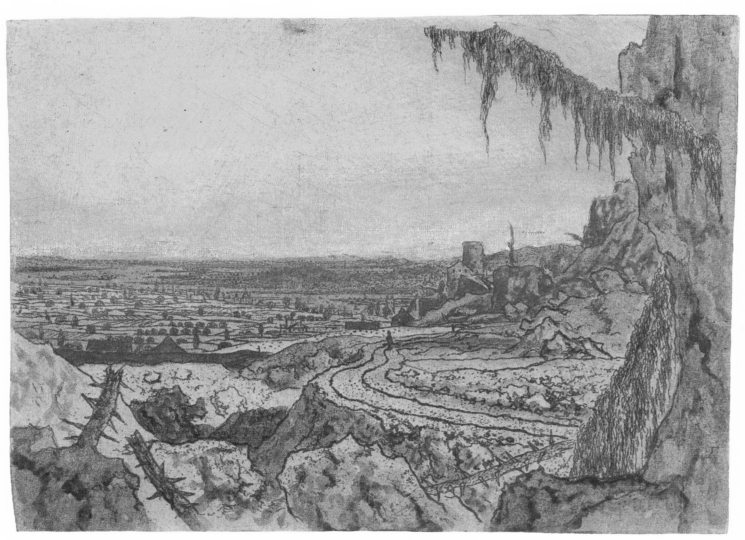

27

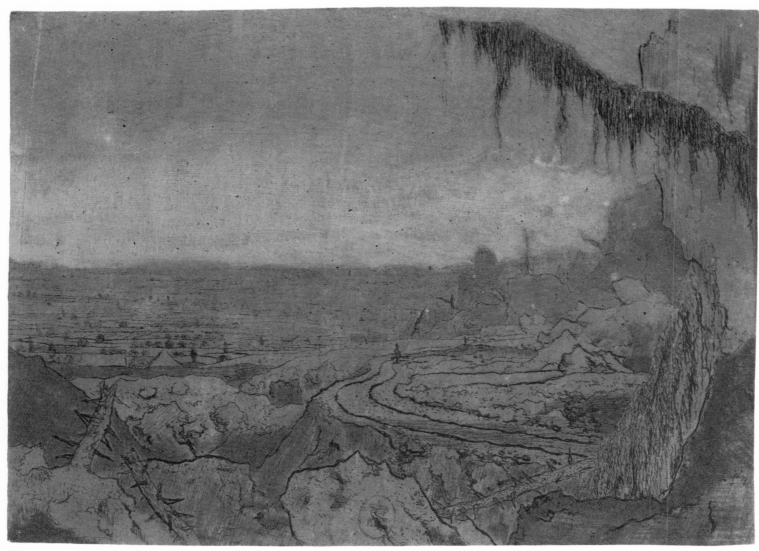

28

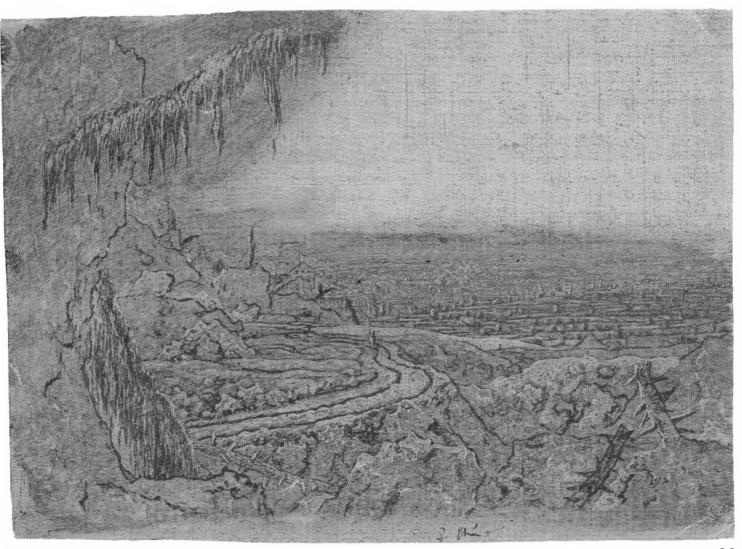

29

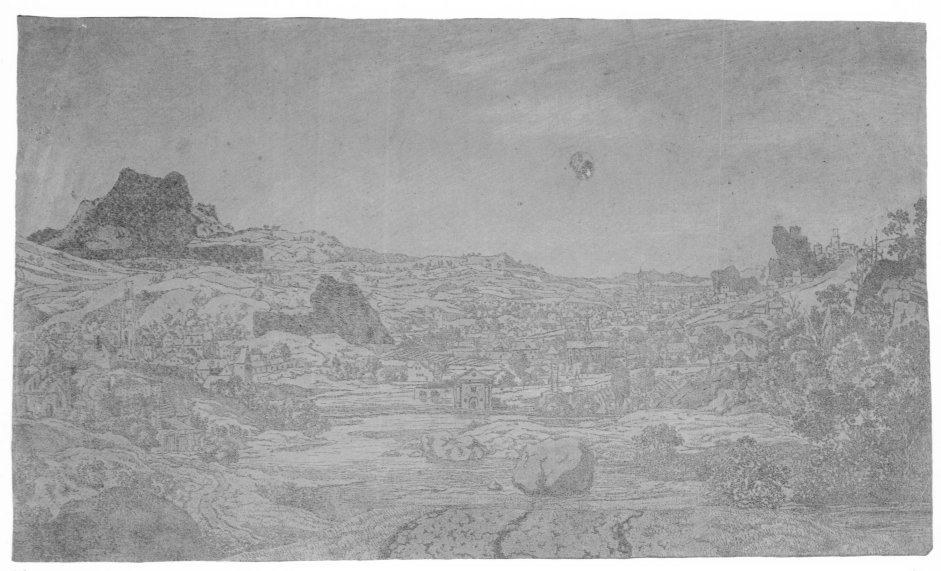

30

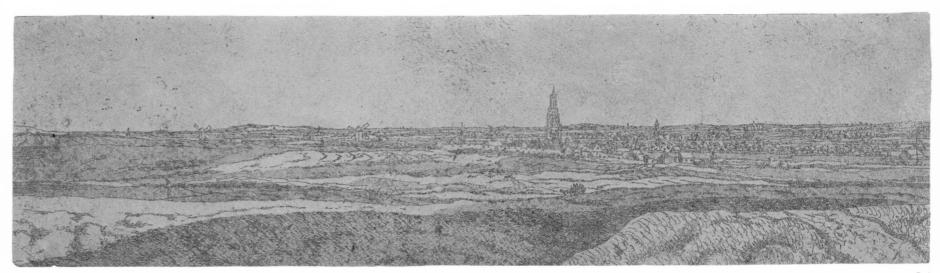

31

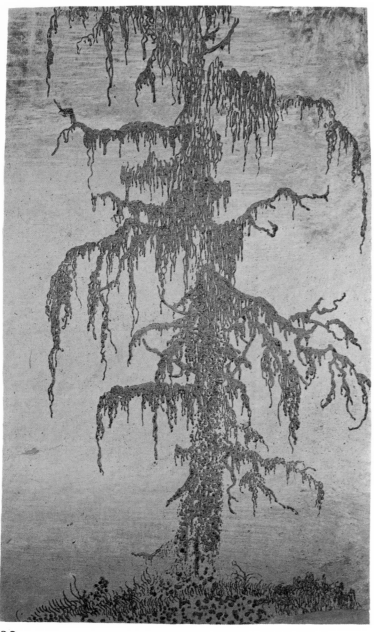

32

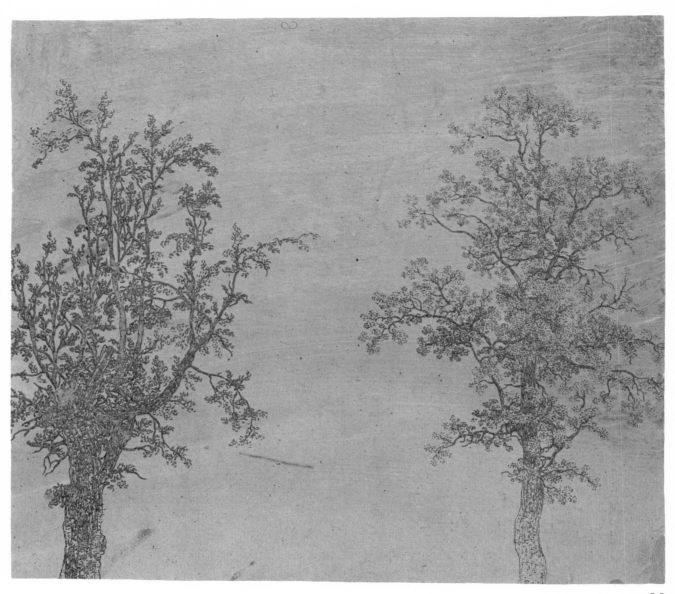

33

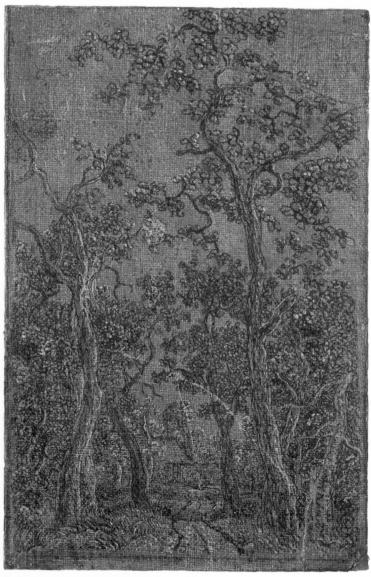

34

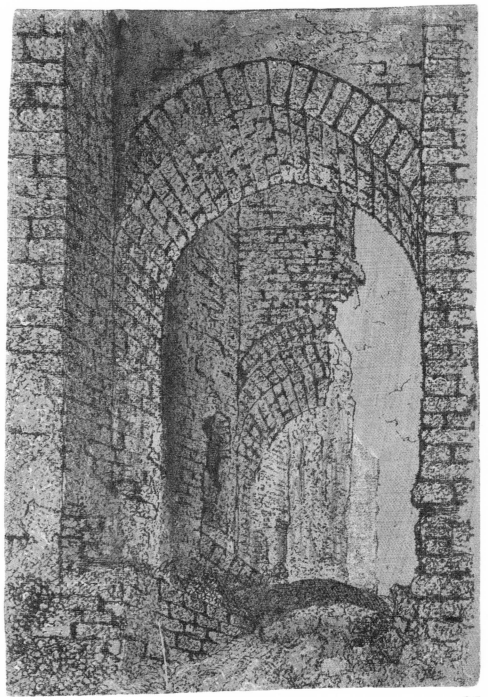

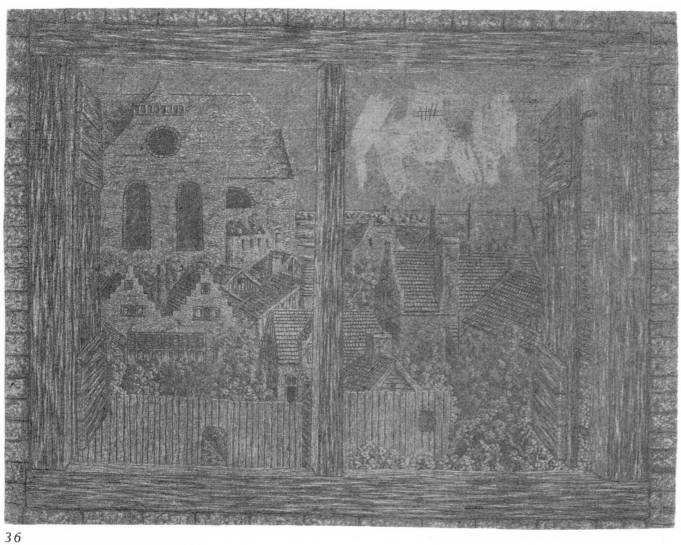

36

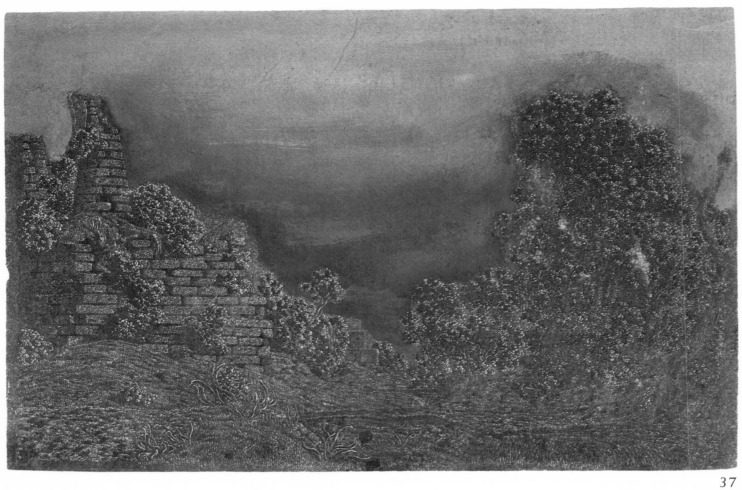

37

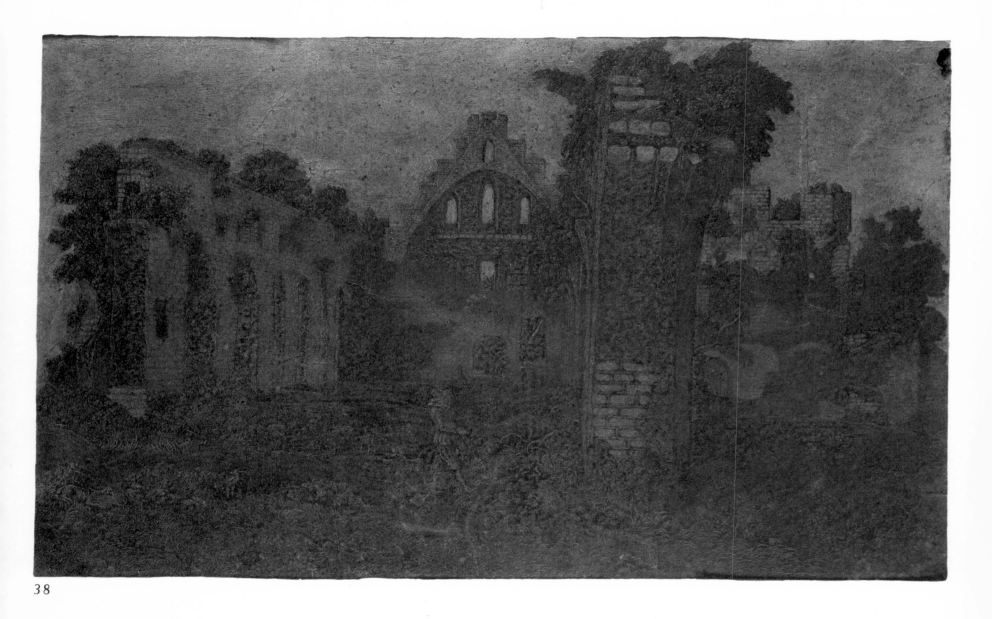

38

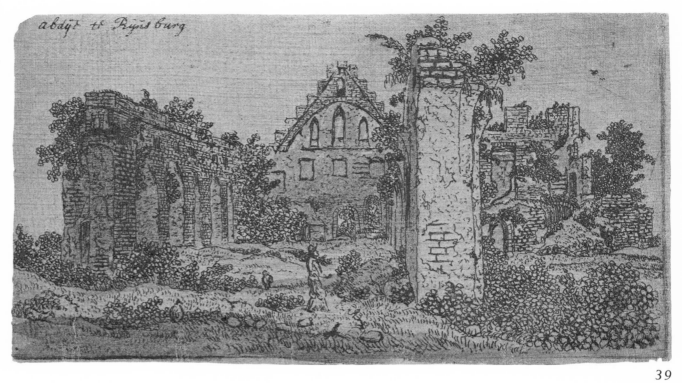

39

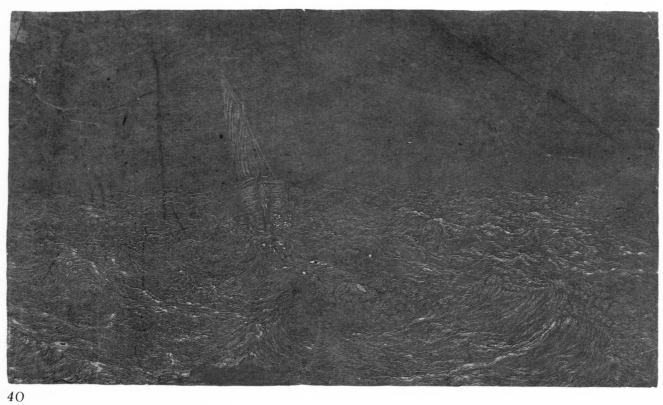

40

Black and White Plates

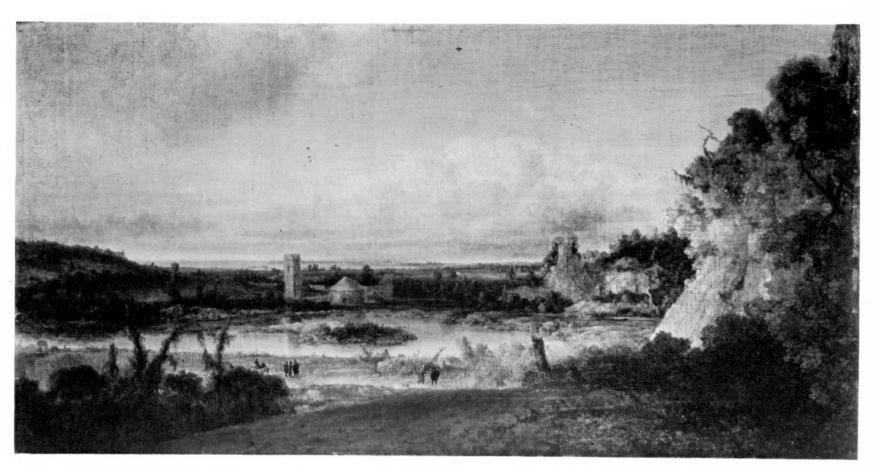

41

42

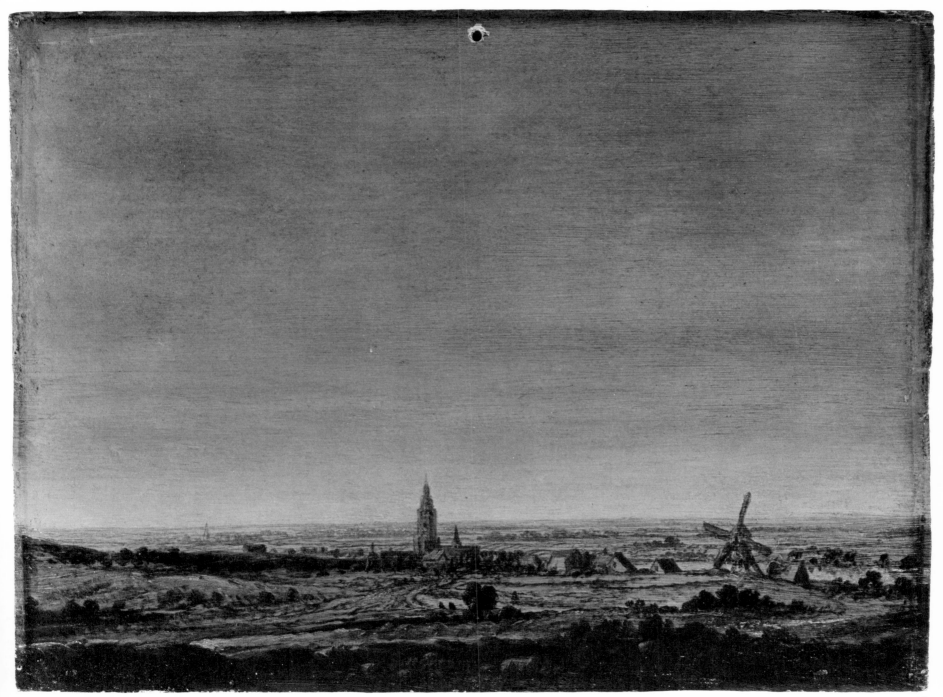

43

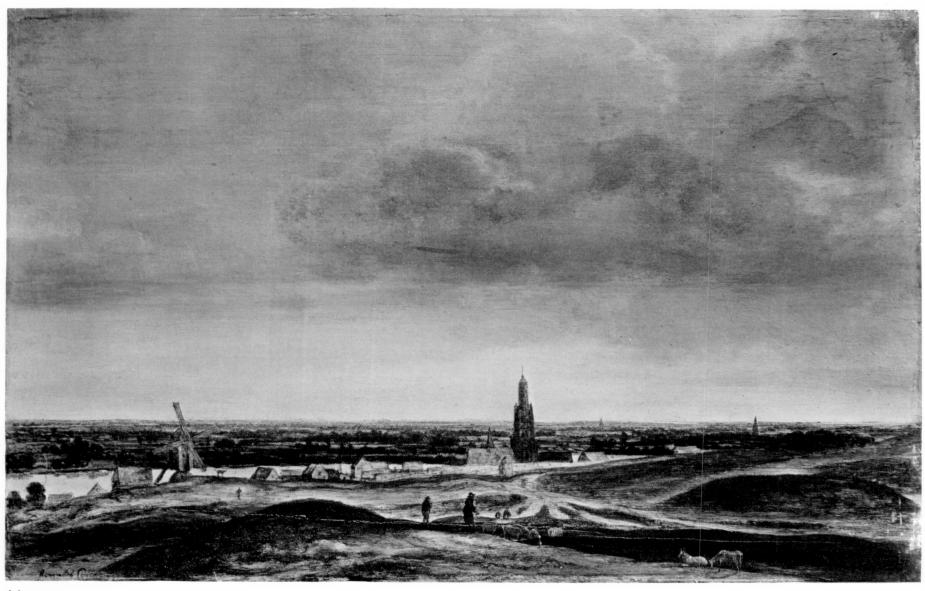

44

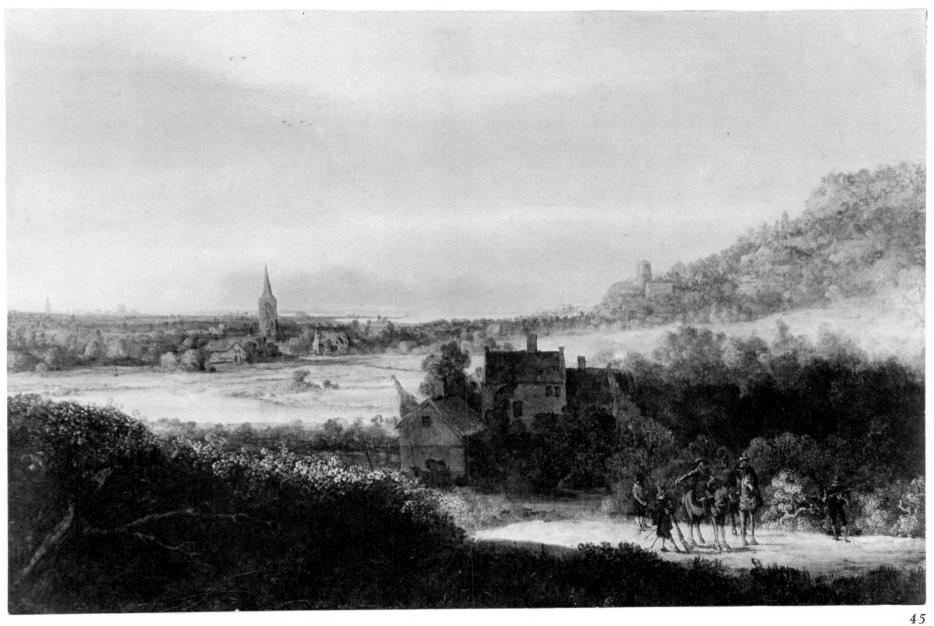

45

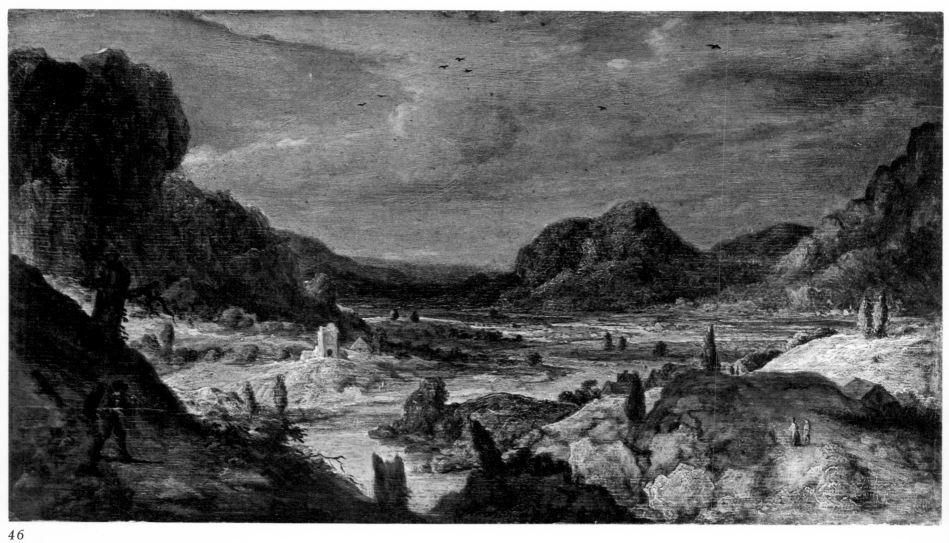

46

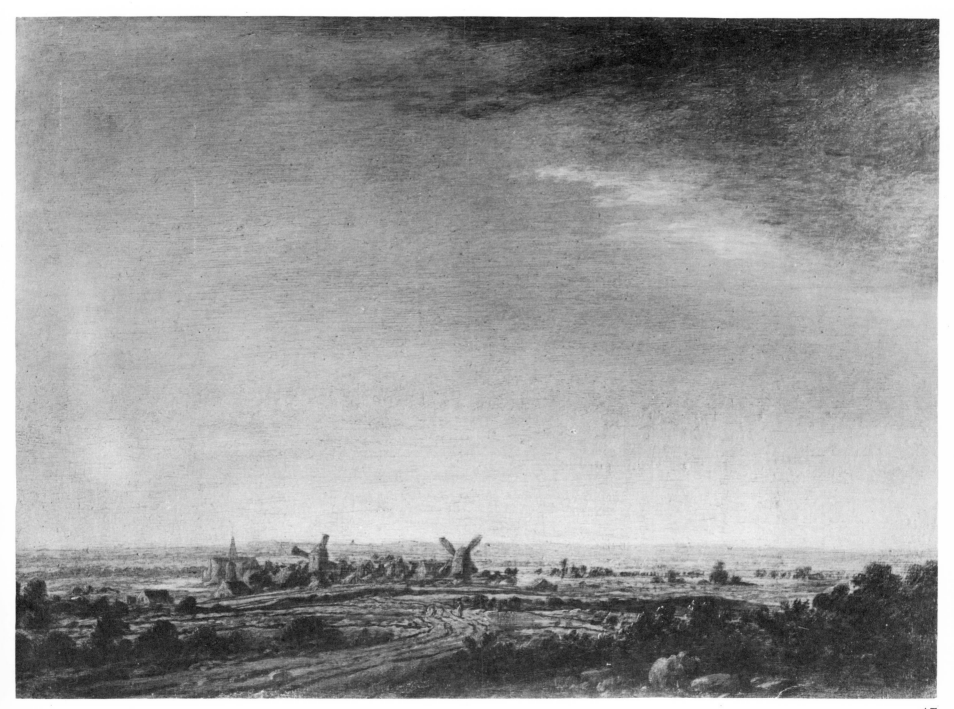

47

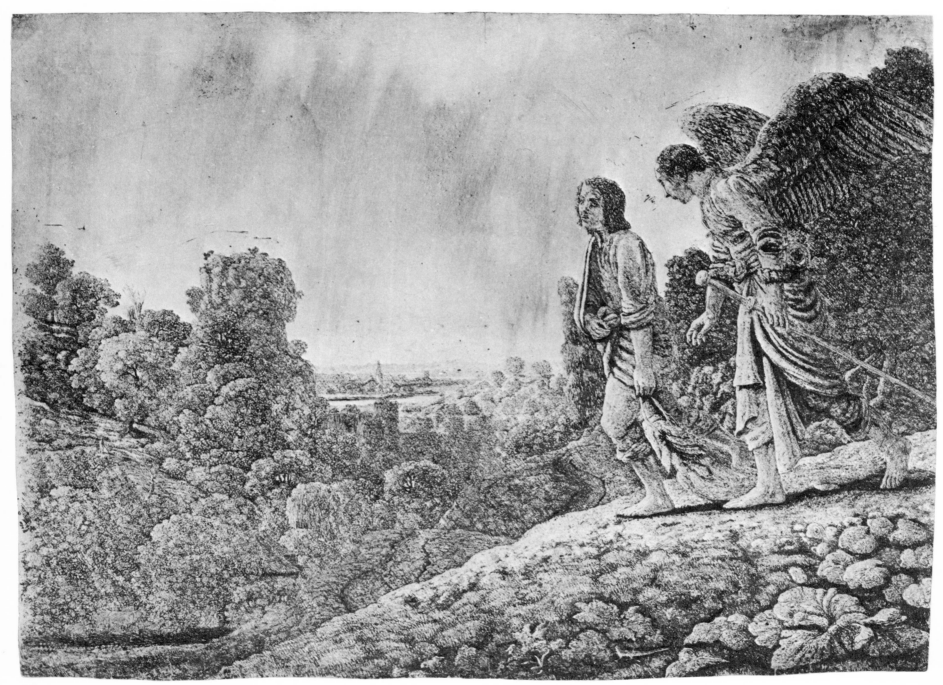

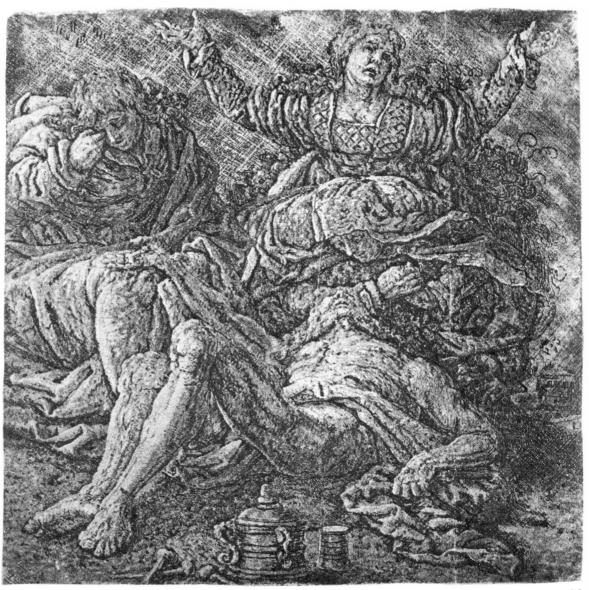

49

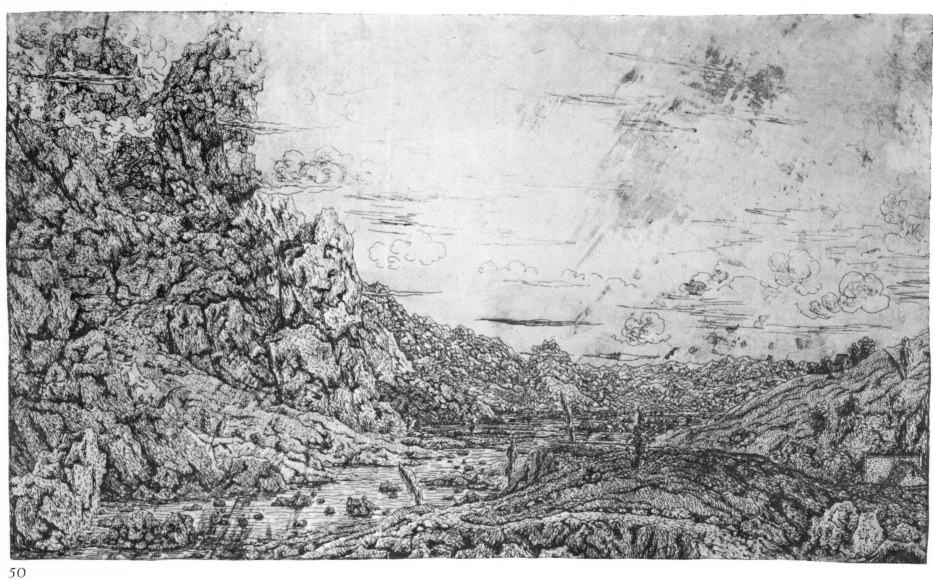

50

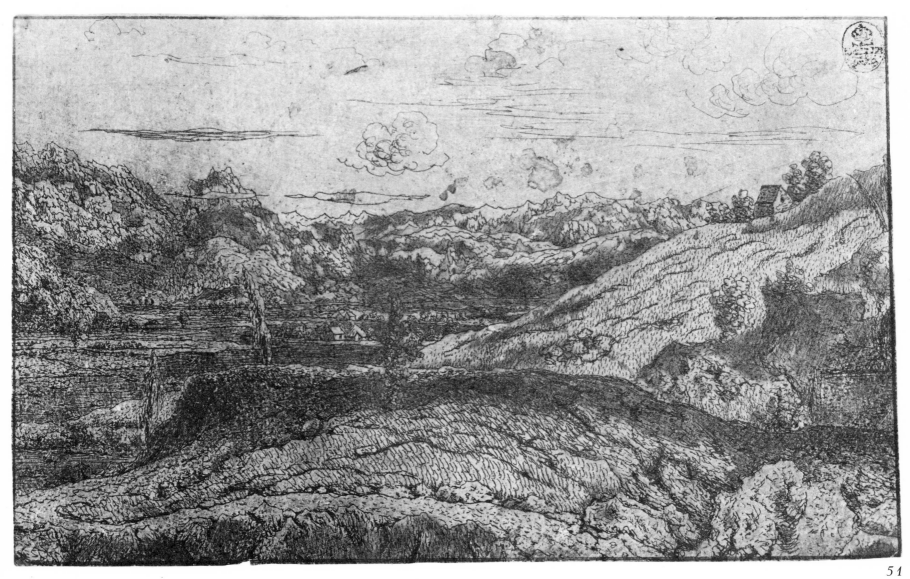

51

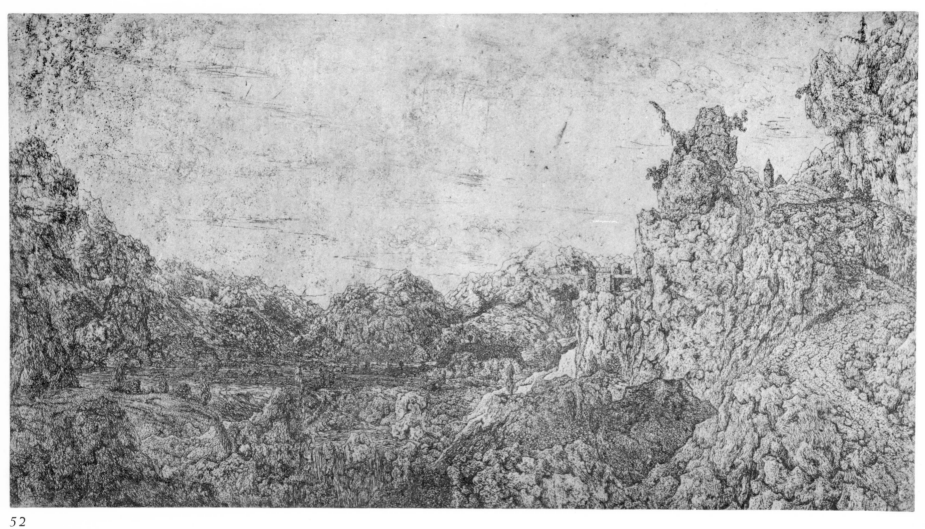

52

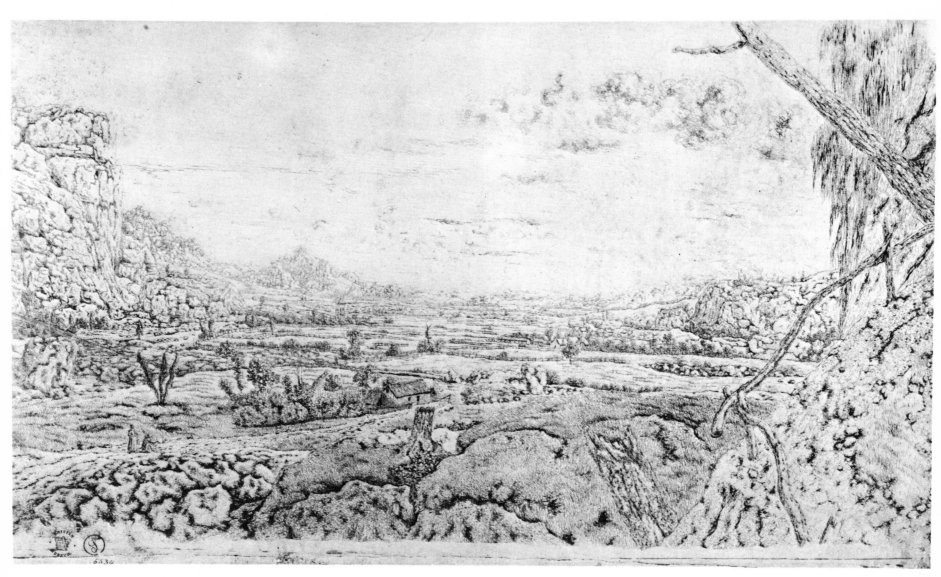

53

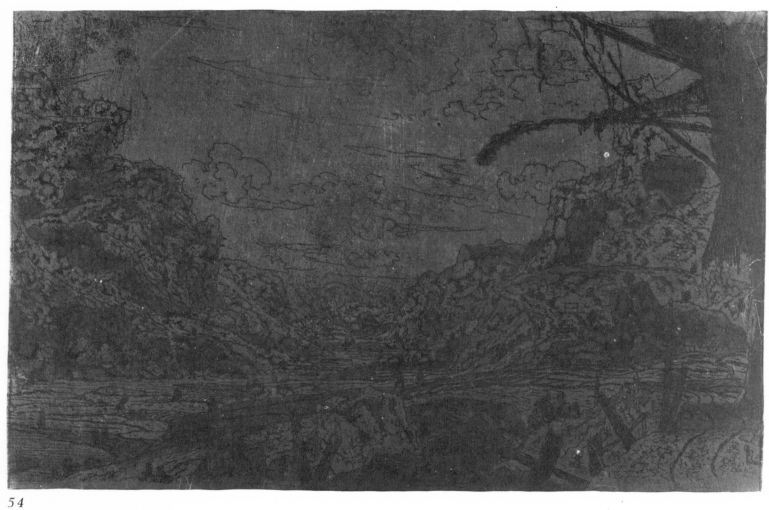

54

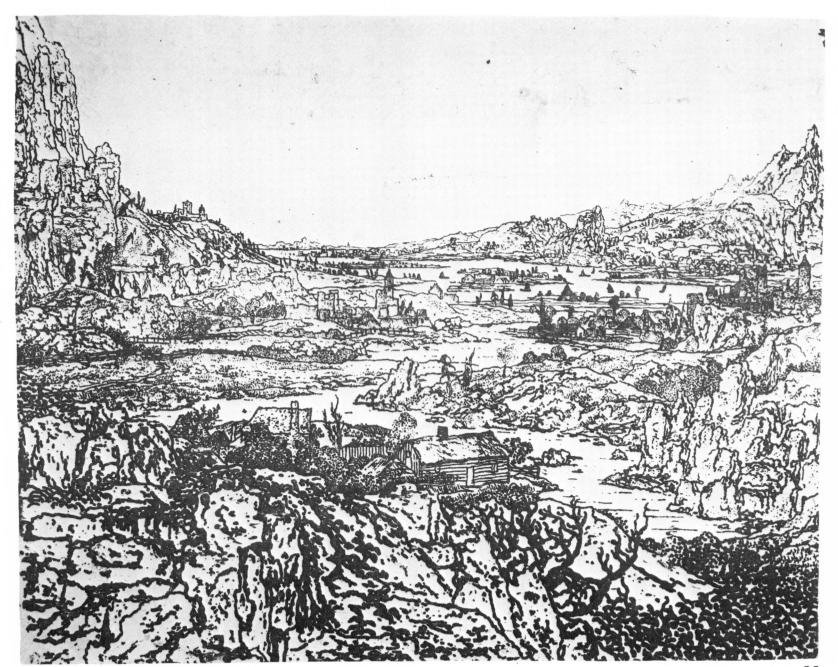

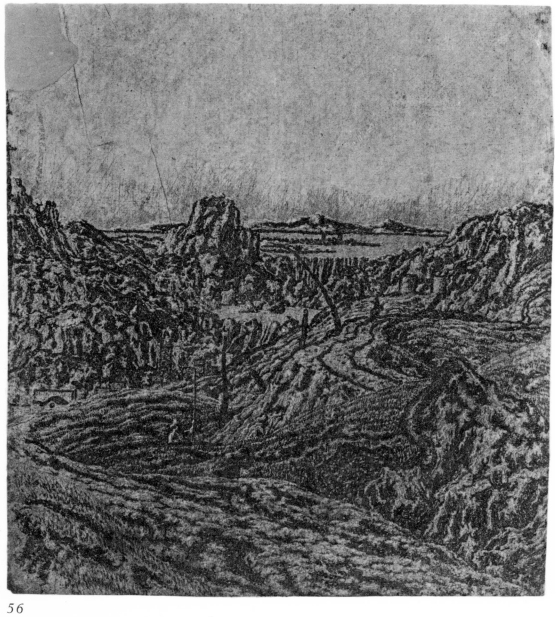

56

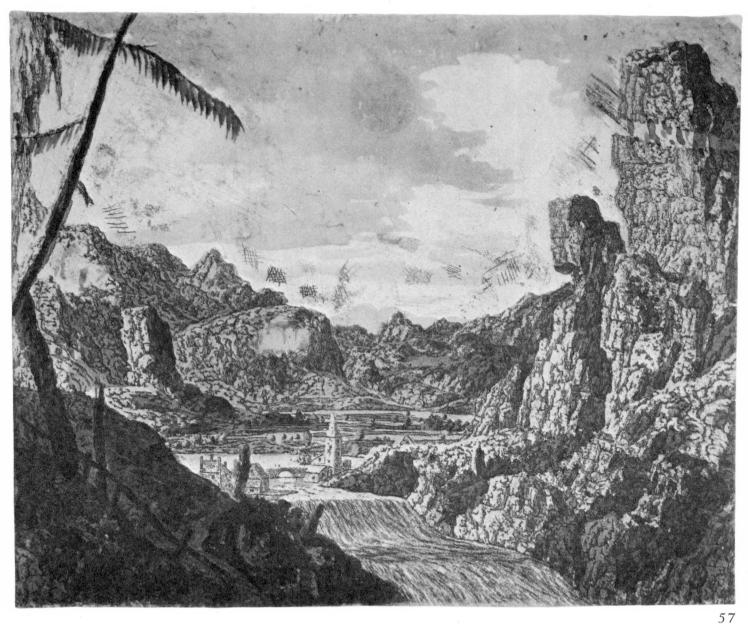

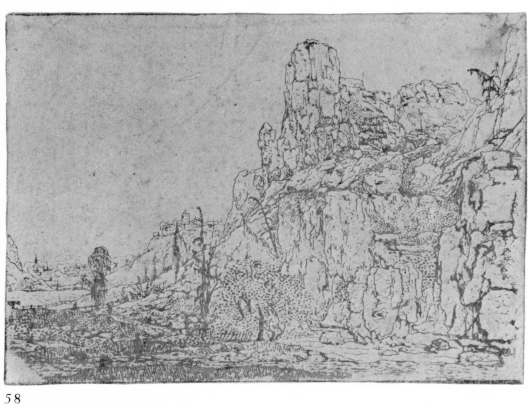

58

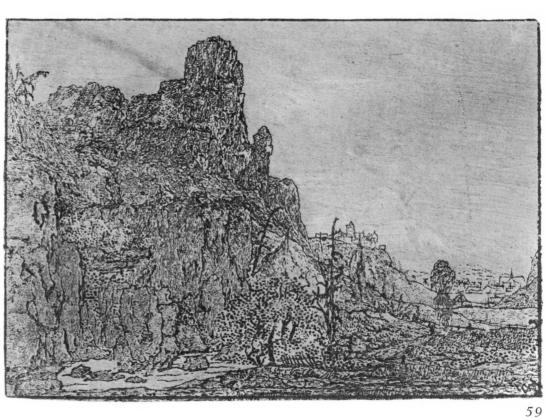

59

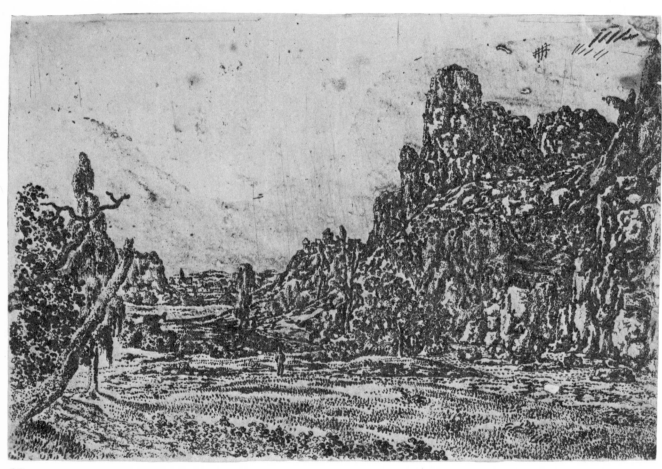

60

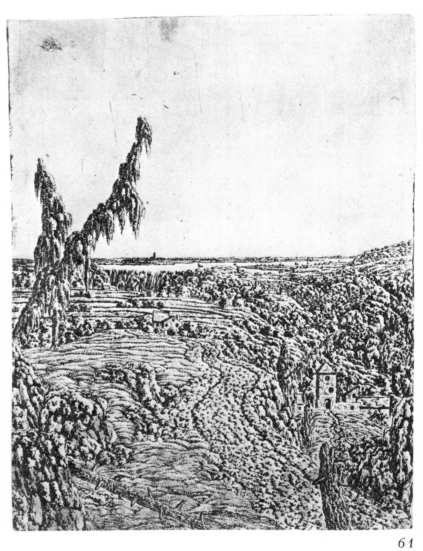

61

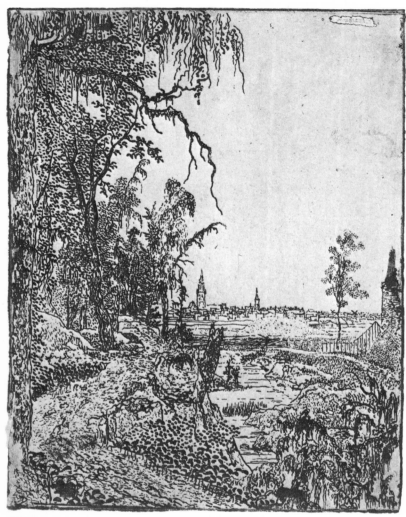

62

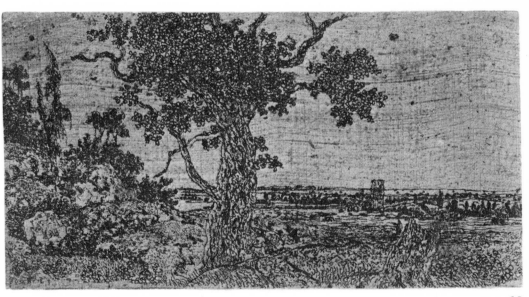

63

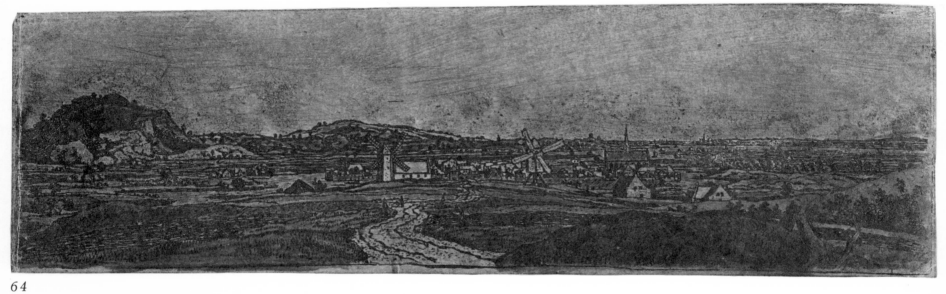

64

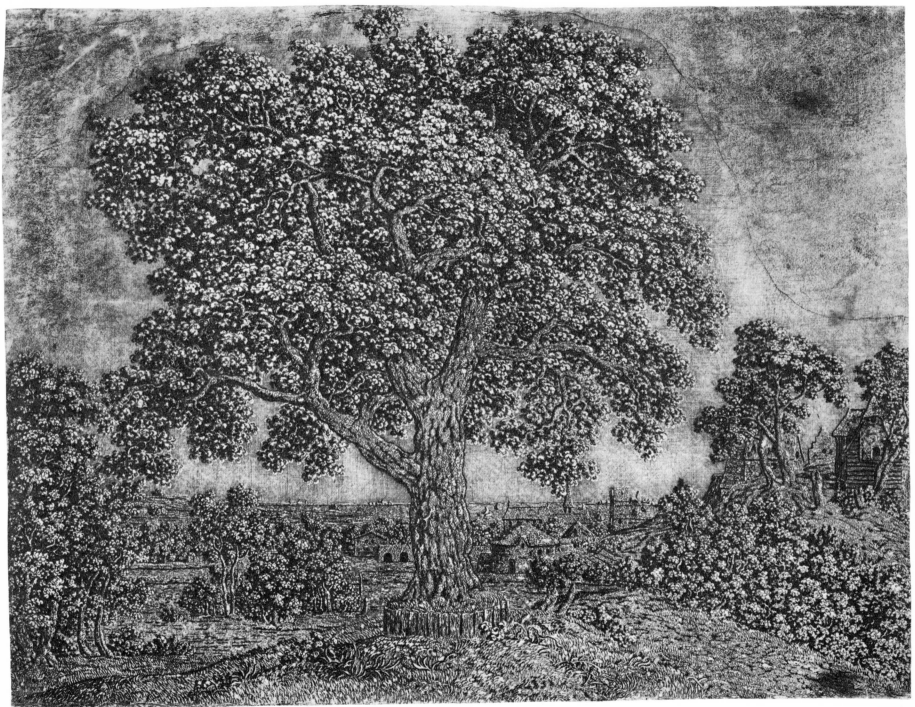

65

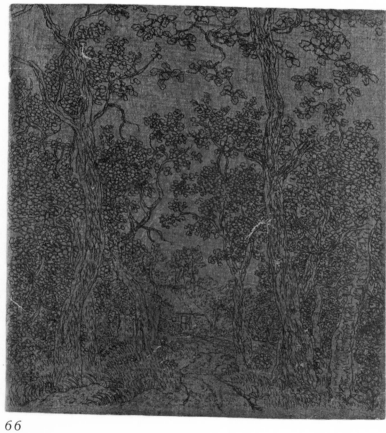

66

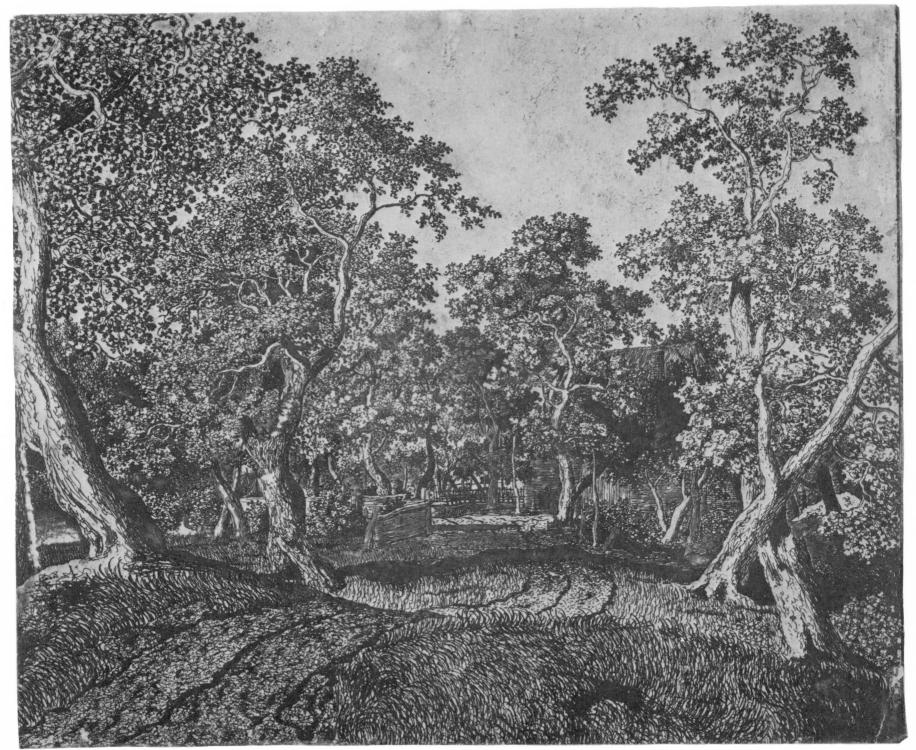

67

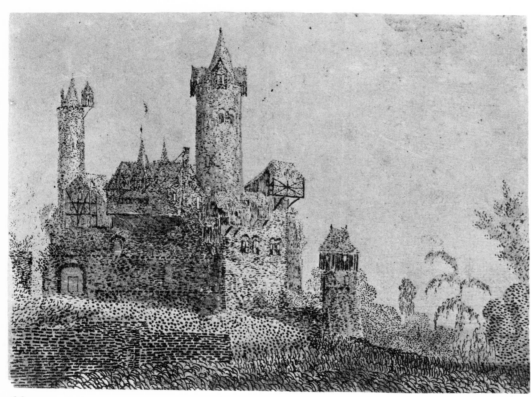

68

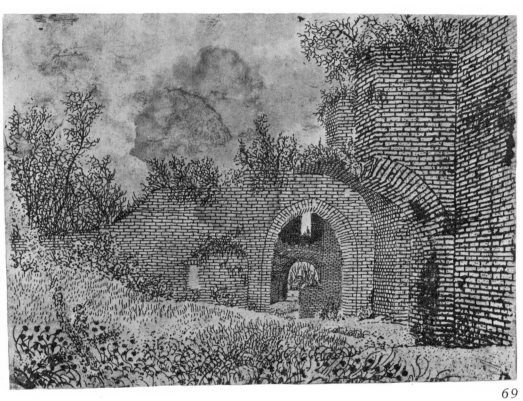

69

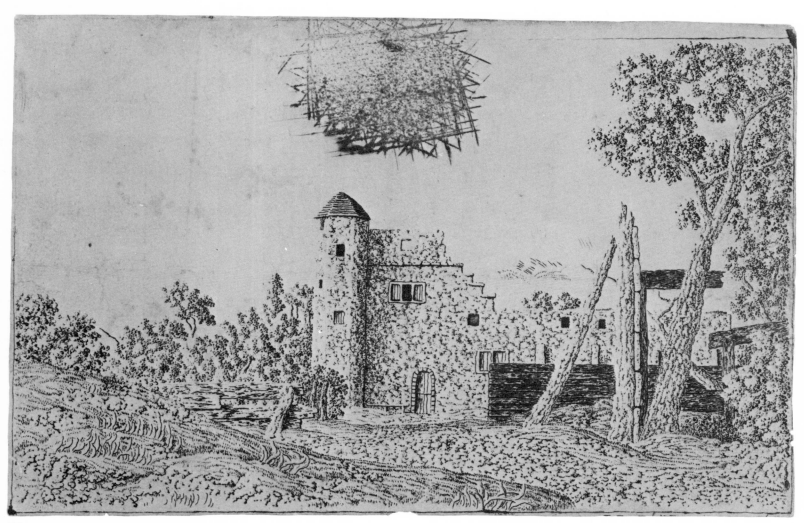

70

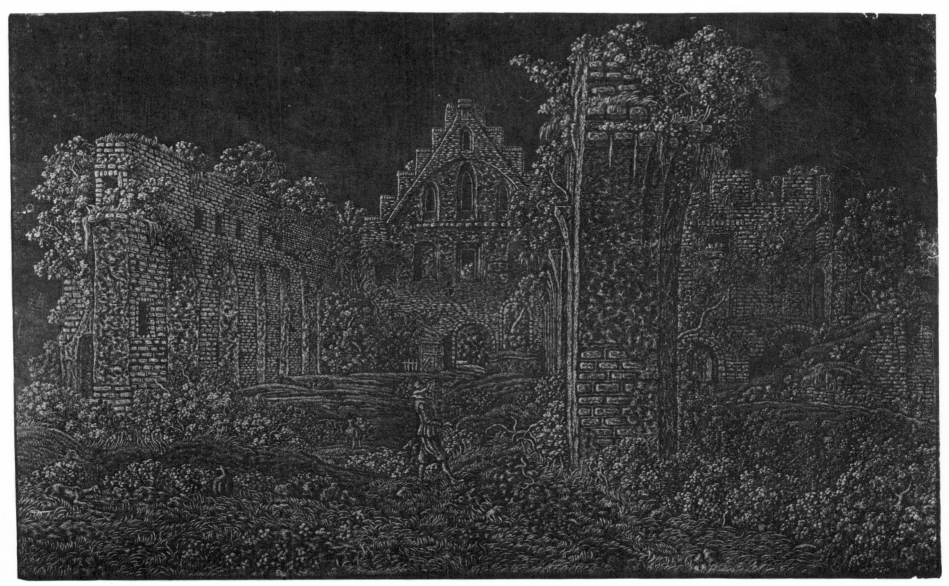

71

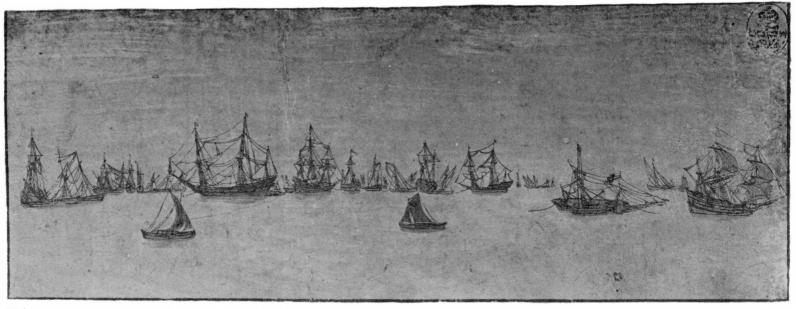

72A.

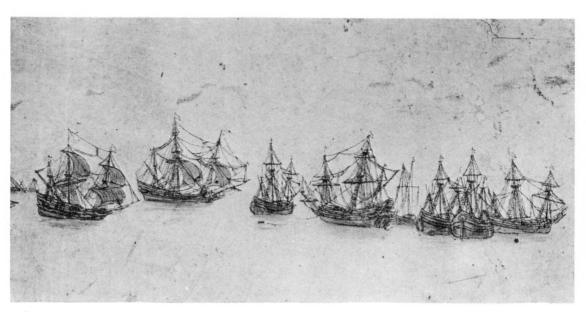

72B.

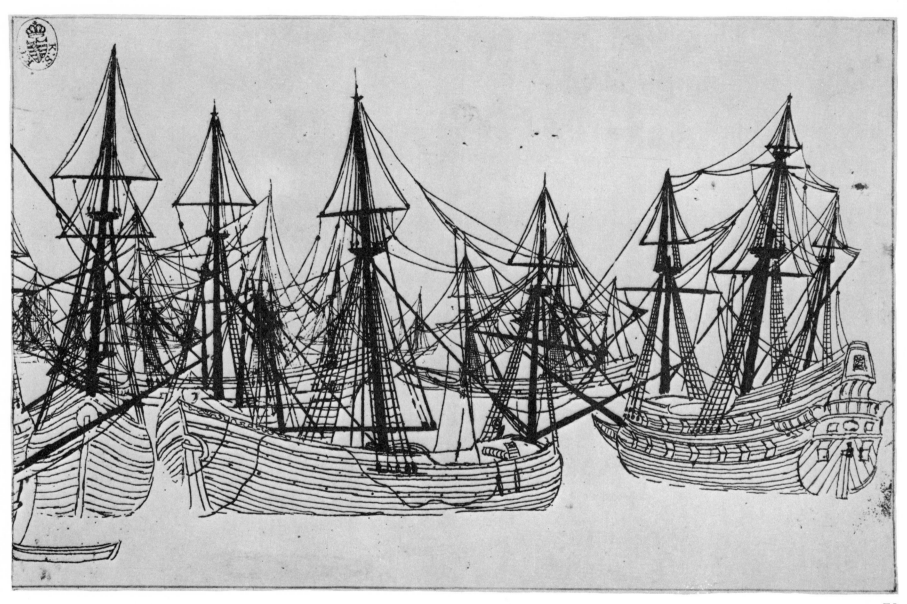

73

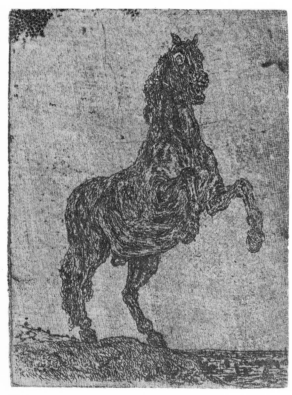

74A.

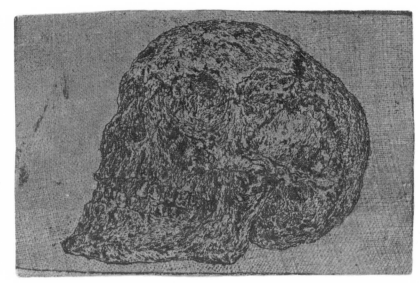

74B.

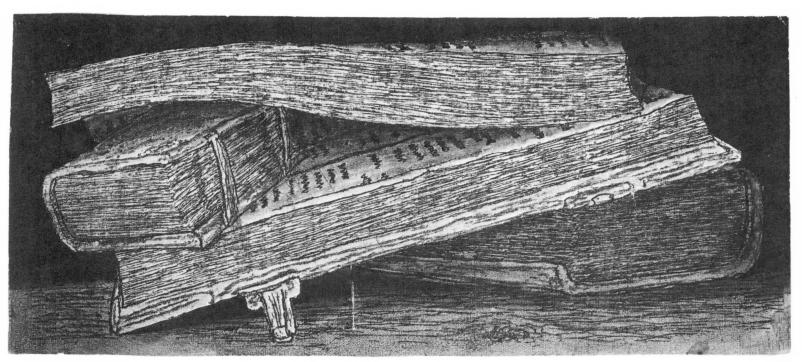

75